NEWCASTLE
THROUGH TIME
A SECOND SELECTION
John Carlson *&* Joyce Carlson

AMBERLEY

Acknowledgements

I would like to thank the following: Howard Goldsborough for writing the introduction, Beamish the North of England Open Air Museum archive staff, Newcastle Library Services, Neil Mortson, Stuart Smith, Mike Taplin, Hugh McAulay, Tony Fox and everyone at Amberley Publishing who helped put this all together. Also, finally, the staff at the University of Newcastle who helped me with a last minute photograph of an amazing view.

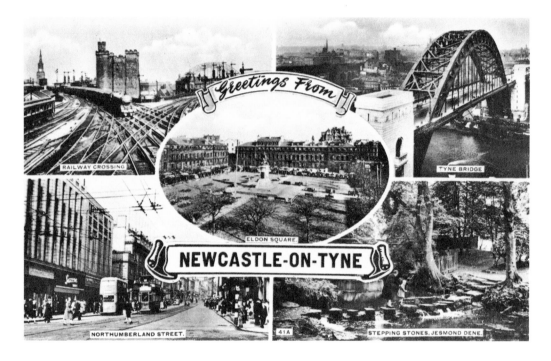

First published 2012

Amberley Publishing
The Hill, Stroud
Gloucestershire, GL5 4EP

www.amberley-books.com

Copyright © John Carlson & Joyce Carlson, 2012

The right of John Carlson & Joyce Carlson to be identified as the Authors of this work has been asserted in accordance with the Copyrights, Designs and Patents Act 1988.

ISBN 978 1 84868 178 1

British Library Cataloguing in Publication Data.
A catalogue record for this book is available from the British Library.

Typeset in 9.5pt on 12pt Celeste.
Typesetting by Amberley Publishing.
Printed in the UK.

Introduction

Hello I suppose I'd better introduce myself: I'm Howard. I'm a long time friend of John's and I hate history.

Well it's all about kings and queens and people and places from years and years ago isn't it? I didn't like history at school so why should I like it now? What's it got to do with me?

Well that's where books like this come in, I suppose, because this is not history. These are the places we have lived in and passed by every day; the stations where we would get the last bus home after a night out; the pubs we used to meet in; the markets and shops we used to go to; the Quayside with all the bonded warehouses that are now apartments, offices, wine bars and law courts. These places were real. Some are long gone, some still here. This is interesting and fun because they bring back memories that we share with our friends and families – this can't be history, can it?

I do remember that my friends and I would meet up and all groan that John had brought his camera with him. We all told him to put the thing away. John took no notice and did his own

thing of taking photographs everywhere we went. Good job he did, because now it's John who has all the reminders of past times and the events that we have forgotten and it's thanks to John and others just like him that we can see these pictures again.

We all have our own memories and different places bring back our own personal recollections of them. Sometimes all it takes is a photograph to remind us of something we had long forgotten. I personally had forgotten about Neil and Affaz posing for their pictures in Newcastle, or Keith on Stephenson's statue, even though I was there. Or even the fact that I had a green check shirt and white trainers – I think I was trying to forget the shirt and trainers mind (thanks for reminding me John).

When John first showed me the photographs, I've got to admit it was just a passing interest (because I don't like history). But as I looked closer the memories came flooding back: of the friends we used to meet at the record shops to the cafés we used to spend hours in to keep out of the rain, the bars that are long gone like the Broken Doll, where Helen and her friends would be lounging around with their pints of Slalom D; or Dave the Punk Rocker who seemed always to be in The Senate Bar. Then down on the Quayside we had The Barley Mow, The Red House, The Cooperage. All of the old bars have changed over the years. In the case of The Barley Mow, all that is left is just a burnt out shell; and The Broken Doll is no longer even there – demolished in the name of progress.

These are just a few of my memories. You, no doubt, will have your own personal, and very different, recollections of different places. The Quayside market with stalls set up in some of the warehouse buildings. Who used to go to the Mayfair night club, now replaced by The Gate?

As I have said, you will all have your own memories and these photographs and pictures will help bring them back. We can all find something different and personal from the same book. The older pictures and photographs are just as relevant as they remind me of how much has changed, and also how much still remains hidden in places by neon and flash shop-fronts or converted into wine bars and trendy restaurants. But at least there are still reminders of bygone days largely ignored but waiting to be rediscovered by anyone who takes the time to look at what's behind the new signs.

I was quite surprised that John asked me to do this foreword for him as I am not a writer and as John knows, I hate history, with its stuffy kings and queens and all that stuff ... but these are real places with real people and I have had a great time recalling some of my past – and yes, reminiscing with friends and family about the past times and places in Newcastle which really did surprise me!

So if I can enjoy this book then well there must be something in it for everyone. Because did I tell you, I hate history?

Thanks to John for putting together some great photographs and pictures, and to Eileen who listened to me moaning about having to do some work and advised me on what to write.

Also thanks to all the people of Newcastle past and present for making this great city the place it is. The city I love.

Howard Goldsborough

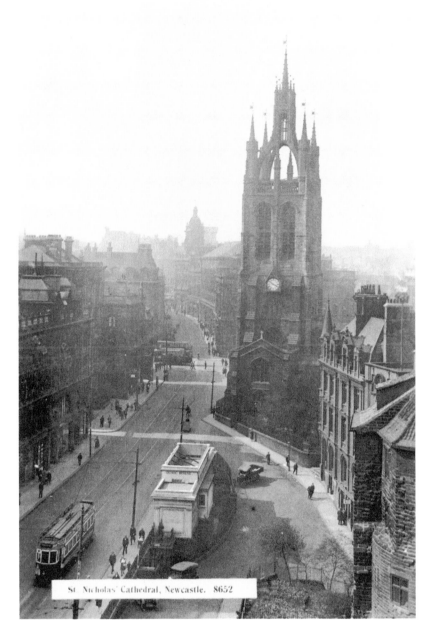

St Nicholas' Cathedral, Newcastle. 8652

The Cathedral Church of St Nicholas

A between the wars view of the Cathedral Church of St Nicholas. We believe the church interior was damaged by Scottish invaders during their brief occupation of the city in 1640, and in 1644, during a nine-week siege, Scottish invaders threatened to bombard the lantern tower, but were deterred when Scottish prisoners were placed inside.

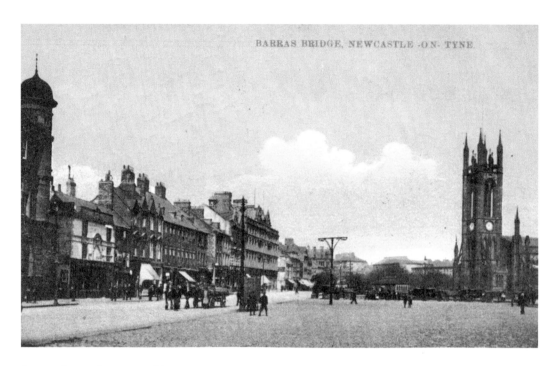

Haymarket and Barras Bridge

Above, an almost idyllic turn-of-the-century postcard view of the Haymarket and Barras Bridge area, looking nothing like the growing transport commercial and intellectual hub it is today. These views actually show how difficult putting together a 'then and now' book can be, as taking the now picture would involve standing in the bus station and probably being questioned by Northumbria police on suspicion of something or other. Below industrial commerciality creeps in in this postcard shot of a traction engine and trailers.

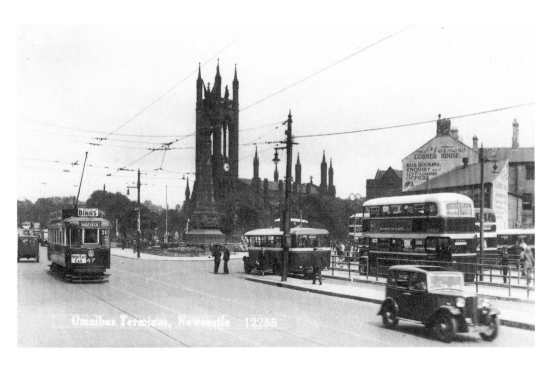

Omnibus Terminus, Newcastle 12255

Haymarket Bus Station

Above, an electric tram rattles through this view from between the wars, but its days are already being debated away by distant government committees as the rise of the internal combustion engine gathers pace. The single overhead tram wire would later be replaced by the double wire of the trolleybus. Below, Haymarket bus station was fondly, or maybe not that fondly, known for its open-air passenger pens.

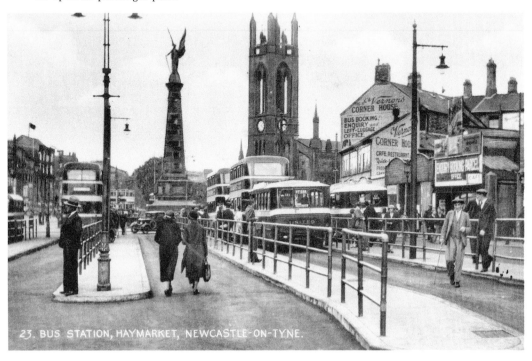

23. BUS STATION, HAYMARKET, NEWCASTLE-ON-TYNE.

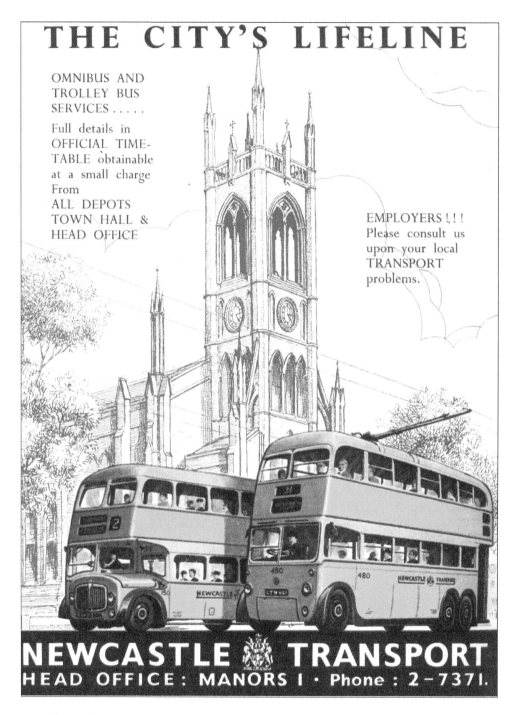

THE CITY'S LIFELINE

OMNIBUS AND
TROLLEY BUS
SERVICES

Full details in
OFFICIAL TIME-
TABLE obtainable
at a small charge
From
ALL DEPOTS
TOWN HALL &
HEAD OFFICE

EMPLOYERS ! ! !
Please consult us
upon your local
TRANSPORT
problems.

NEWCASTLE TRANSPORT
HEAD OFFICE: MANORS I · Phone : 2-7371.

Transport Undertaking

The point of contact between a municipal Corporation and the population it served was often in its transport undertaking. The importance of good public transportation in an area like Newcastle is stated well in this image. Other operators in the area included Northern General, Gateshead & District, Sunderland District, Venture, United and Tynemouth/Wakefields, but many other smaller independent companies operated in the city over the years.

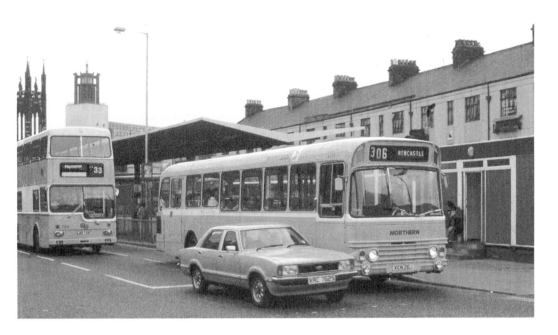

Percy Street

A Mark IV Cortina Saloon illustrates how public transport was being, for many, replaced by private transport in this late 1970s view. The Haymarket bus station is now covered, doubtless to the relief on many passengers. Below ground, work would be underway on the Tyne and Wear Metro system. The buildings behind were looking their age and Marks & Spencer's on Percy Street would be seeing trade increase. Below, the private company Stagecoach now ran the Corporation's former routes and Marks & Spencer's have bought, demolished and replaced the buildings.

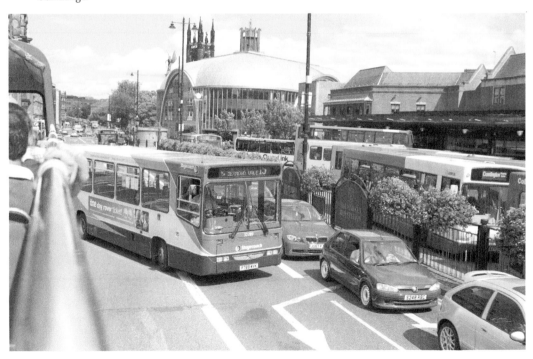

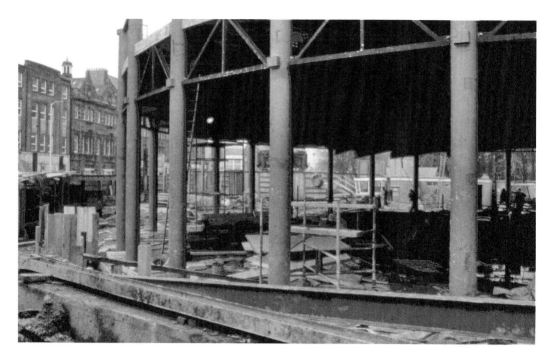

Haymarket Metro Station I

The Haymarket Metro station was the metro system's first city centre terminus when it opened to passengers in 1980. The circular surface building was something of a local icon for a while but the commercial opportunities offered by the site began to be appreciated, with suggestions appearing that a revolving, or maybe just round, restaurant should be built on top. In the new century came plans for more complex and complete rebuilding and refurbishment of the Metro station in the £20 million 'Haymarket Hub' project announced in 2006. Below, the southbound platform during refurbishment work for the Hub project.

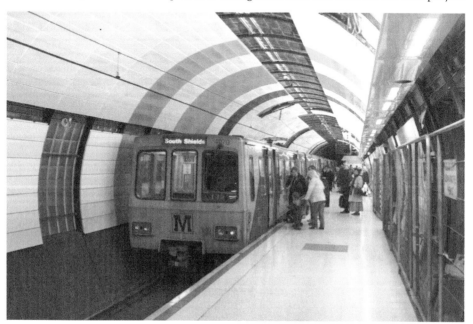

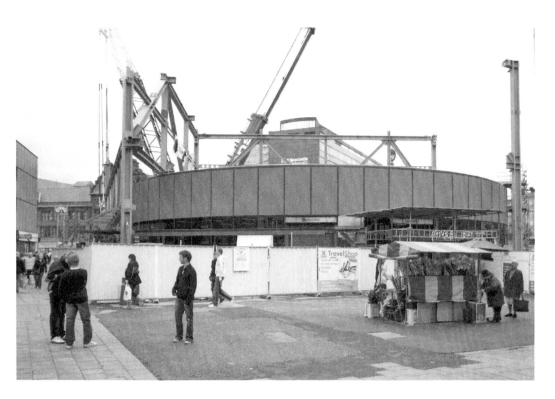

Haymarket Metro Station II

The project involved constructing a much larger property around and on top of the existing building. When the new building was finished the old one was simply cut away with torches. While some view the new structure differently to others, it has certainly proven popular, with many of its units being quickly let.

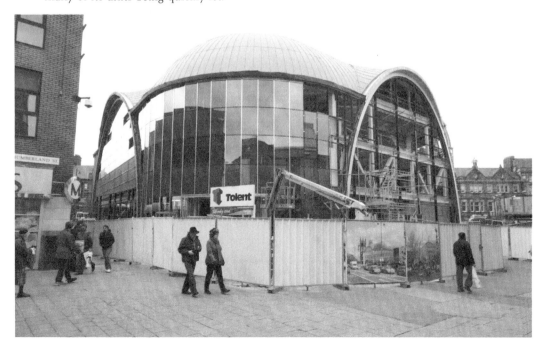

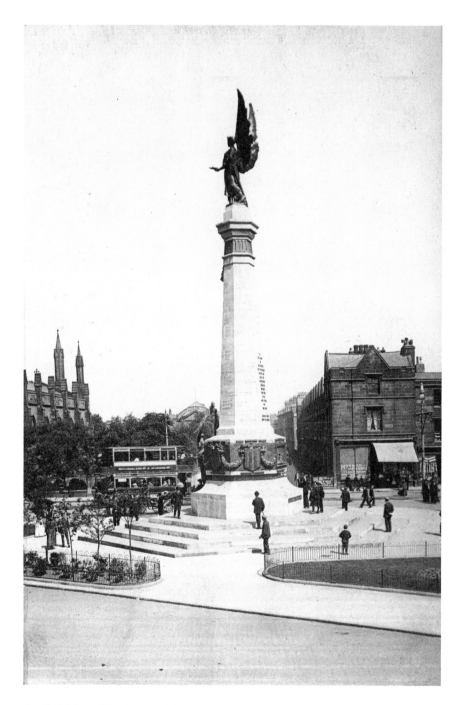

South African War Memorial

The South African War Memorial at the Haymarket has been one of the constants in the changes that have swept through the area, although it has had a slightly complicated history. Unveiled in 1908, the monument has often been caught up in building work around the area and in the '70s the figure of 'Victory' was taken down for a while due to fears of damage by Metro construction work. When it was later put back, its wings had been replaced by fibreglass copies.

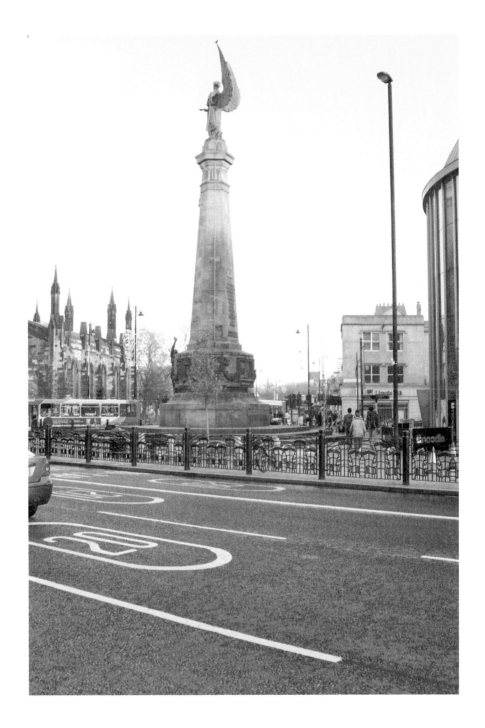

In the later years of the last century it was surrounded by controversial sculptures of fifty-two men standing shoulder to shoulder, which became known as the 'Lego Men'. The sculpture also incorporated a water feature which caused problems. Another constant in the area but out of view here has been the Church of St Thomas the Martyr, which is known for its liberal views and eager involvement in social issues both in the city and internationally.

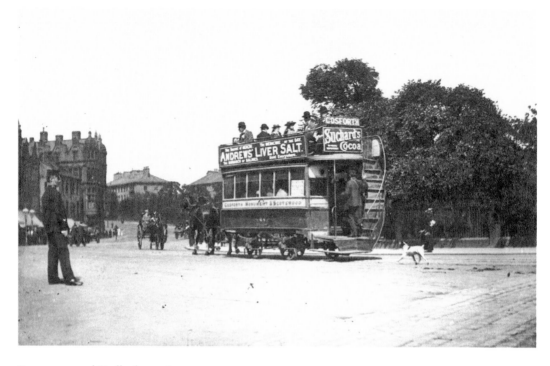

Tramways and Trolleybuses I

Views in the Barras Bridge direction illustrating the development of the area. Horse trams began in Newcastle in 1879 run by the Newcastle & Gosforth Tramways & Carriage Company. The electric cars replaced them in 1901, this time run by the Corporation.

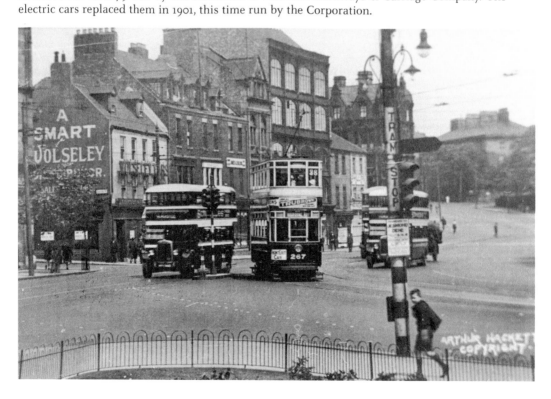

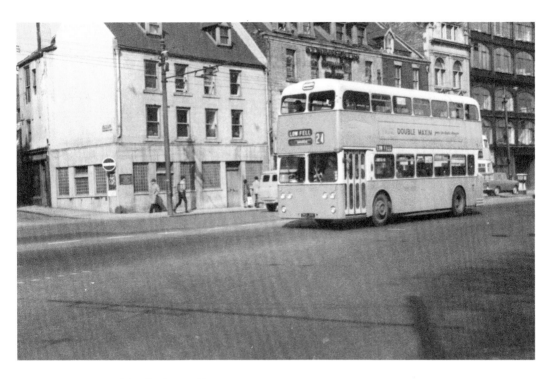

Tramways and Trolleybuses II

While the Corporation did develop its system, building new cars and refurbishing existing cars for its fleet, trolleybuses were introduced in 1935 and it was only the onset of the Second World War that allowed its tramways to make it into the 1950s. They were abandoned on 4 March 1950. That wasn't quite the end for tramways in the city and trams from Gateshead still crossed the Tyne and ran onto Corporation tracks until 4 August the following year. The last of these images also shows the recent strong growth of the University of Newcastle.

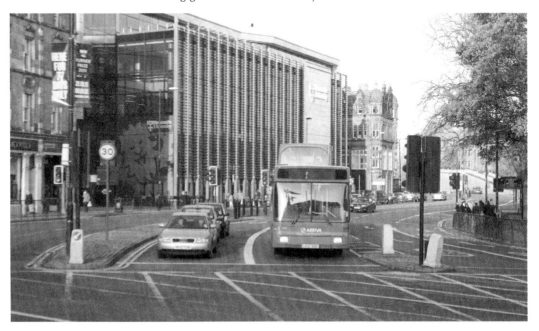

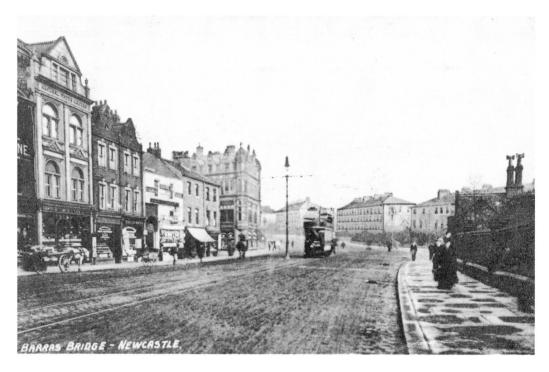

Barras Bridge I

Barras Bridge shortly after the century's turn and below at the end of 2011. Other than the differences apparent on the road the most obvious development is the appearance of the £22 million Newcastle University Kings Gate building. This structure houses the University's student services department and is known as its front door.

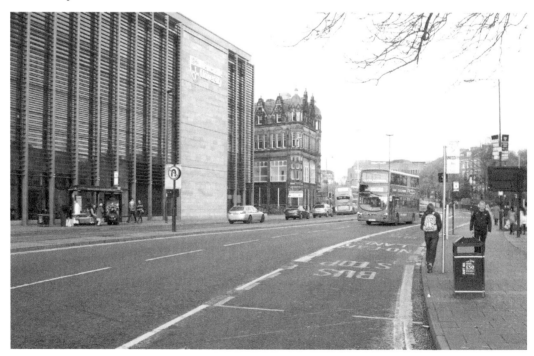

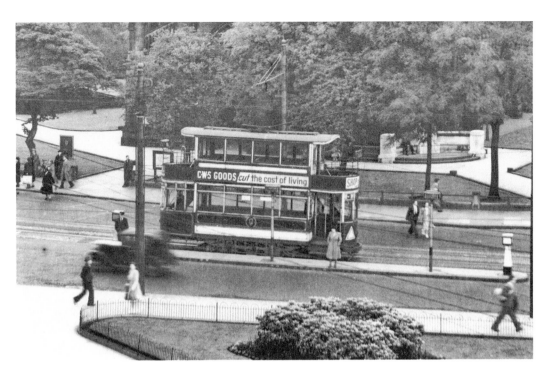

Barras Bridge II
A Gateshead & District tramcar on a cross Tyne service running past Barras Bridge. The Corporation and Gateshead services were so integrated they almost operated as one system. The area behind the car is occupied by the west end of St Thomas' church and the Civic Centre is far off to the left. Below, a similar view taken as winter approaches in 2011.

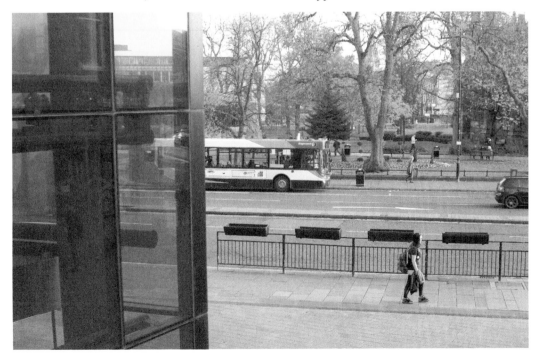

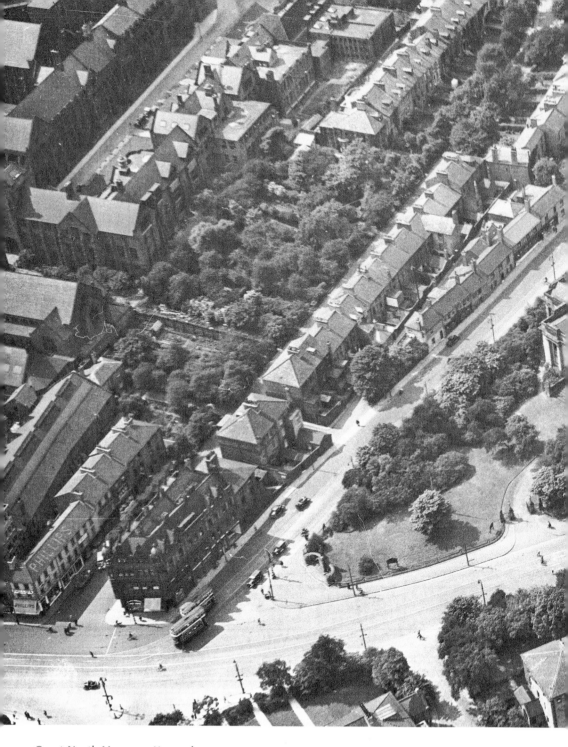

Great North Museum: Hancock

An aerial shot of the area around the former Natural History Museum known today as the Great North Museum: Hancock. Originally the building cost upwards of £40,000, a sum which was largely contributed by W. C. Henderson and Sir W. G. and Lady Armstrong. After the Second World War, the museum began to slowly fall into a state of disrepair. After an arrangement was

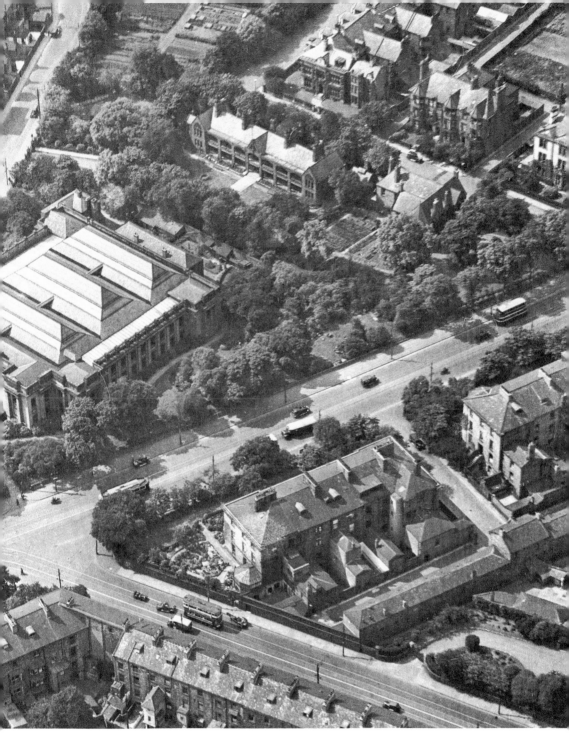

struck with the University of Newcastle, the Hancock Museum closed its doors to the public in April 2006 and in a £26 million project it was transformed into the Great North Museum: Hancock, which reopened in May 2009. The Great North Museum incorporates collections from the Hancock Museum and Newcastle University's Museum of Antiquities, the Shefton Museum and the Hatton Gallery, and includes a large-scale interactive model of Hadrian's Wall.

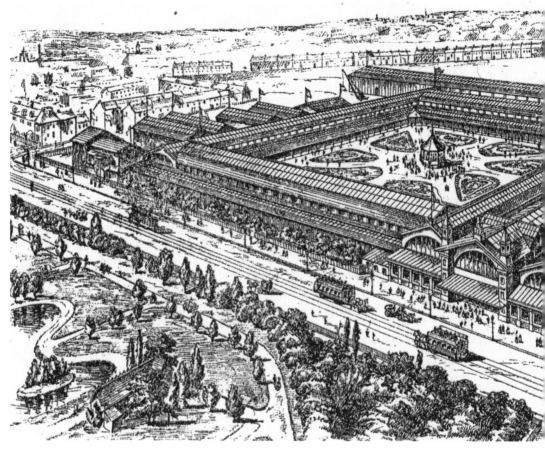

Exhibition Park
An engraving of the Exhibition Park area. We believe this shows the jubilee exhibition of 1887.

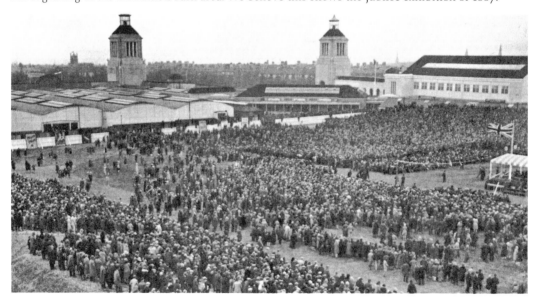

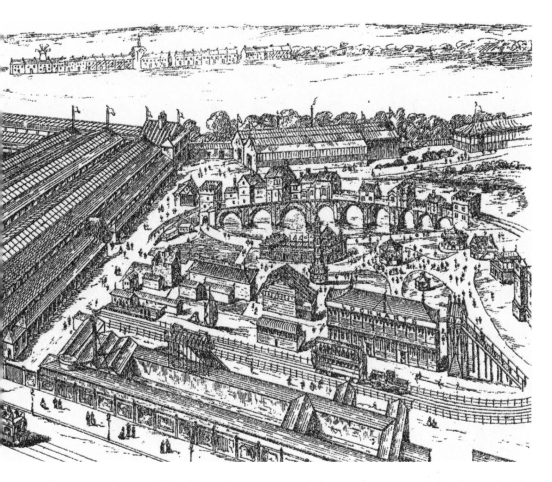

The site was later used by the North East Coast Exhibition of 1929, seen below left and right, which almost 4½ million people attended.

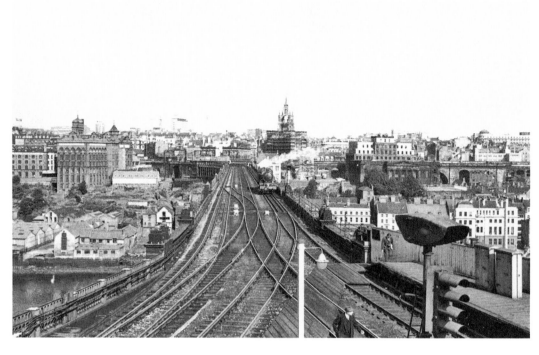

Newcastle Seen from the Former Footbridge at Gateshead Station I

The image was taken to show the British Railways locomotive Clun Castle at Tyneside while it was undergoing, we believe, gauging trials at Gateshead in the mid-1960s. Although the locomotive appears here in Great Western livery, it was actually built at Swindon works in 1950 after the nationalisation of the railways in 1948. As the footbridge is long gone and we were not into trespassing on the top deck of the High Level Bridge we couldn't take a direct 'now' view of this, but include below an image taken from either side of the bridge's road deck.

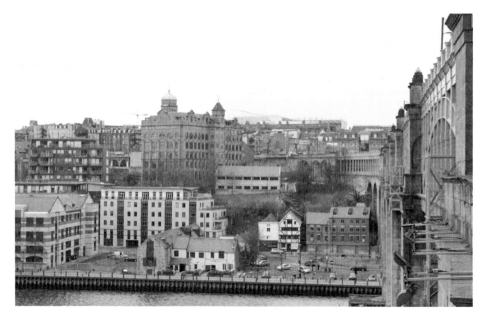

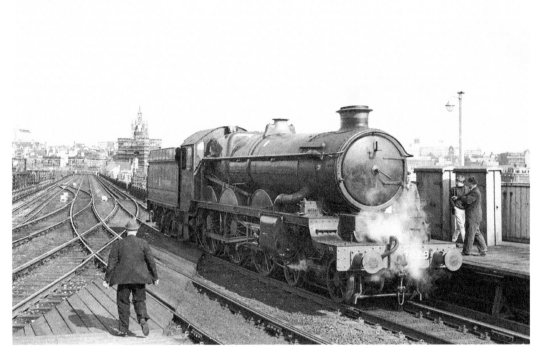

Newcastle Seen from the Former Footbridge at Gateshead Station II
A closer photograph of the locomotive as it nears the platform. The quayside area has seen some major changes in use and appearance, although thankfully many of the interesting buildings remain.

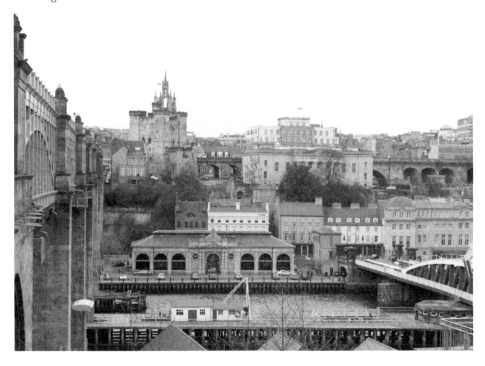

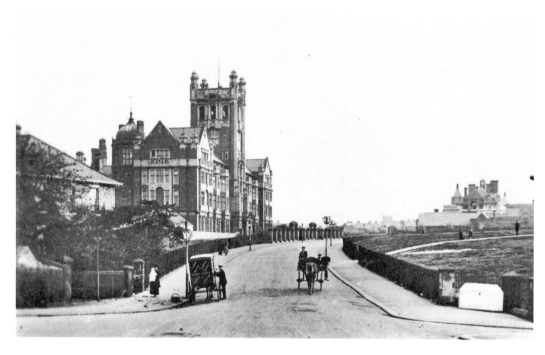

Queen Victoria Road from Exhibition Park

The University of Newcastle has had a fair share of its graduates go on to become household names including Kate Adie, Rowan Atkinson, Brian Ferry, Mo Molam and Alan Plater. The Students' Union has seen many popular entertainers such as Maximo Park, Snow Patrol, Kosheen, The Fratellis, Coldplay, Low, Mercury Rev, Goldie Lookin' Chain, Chicane, The Hoosiers and Damien Rice. The student newspaper, *The Courier*, won the *Guardian*'s 'Student Newspaper of the Year Award'.

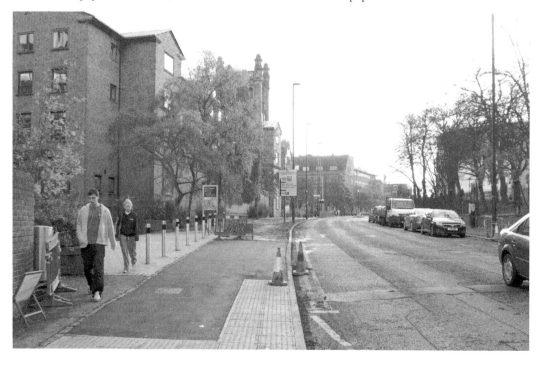

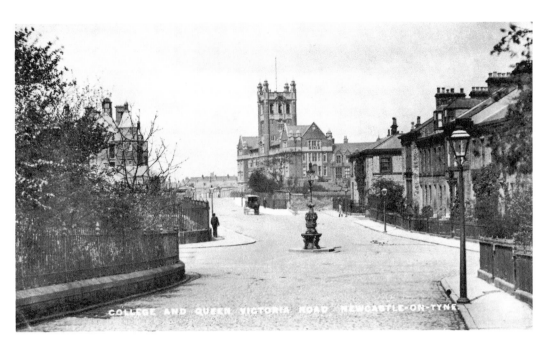

Queen Victoria Road

Looking along Queen Victoria Road in both the early twentieth and twenty-first centuries, showing its development. Behind the camera is the world-famous Trent House pub, which we really should have thought to feature in this book. However, the Royal Victoria Infirmary is to the left of the images with the university to the right. Today's city sightseeing open-top bus tour which passes along this road recounts that, due to a misunderstanding over the payment of a bill, Newcastle lost favour with Queen Victoria and later she would always close her blind when travelling through the city by train. Upon her death she left an item of her underwear to the RVI to show her contempt for the city. Above, Queen Victoria Road looking towards the Exhibition Park area.

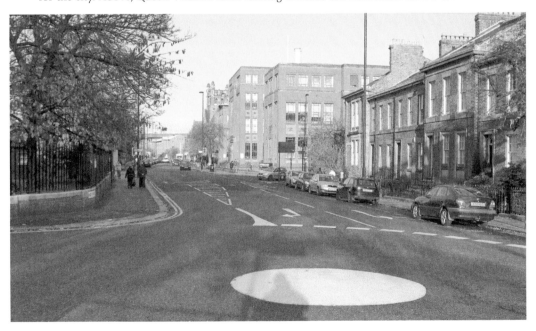

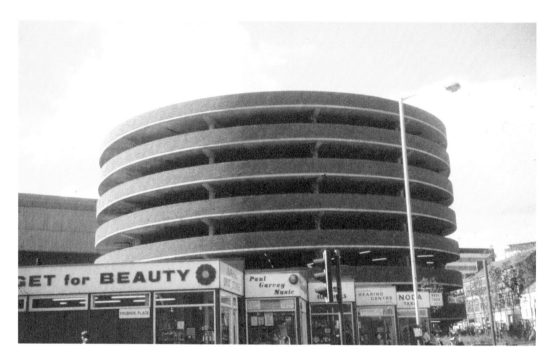

Eldon Square Shopping Complex

Eldon Square opened its doors to the public in 1977 and has had seemingly endless extensions, upgrades and improvements ever since. Its success can perhaps be judged by around a third of it, the Greenmarket area, being knocked completely flat and then rebuilt again around 2008. One constant feature has been the multi-storey car park about which we could find little information other than it holds a safe parking award and a year's parking we believe can be had for £1,664.

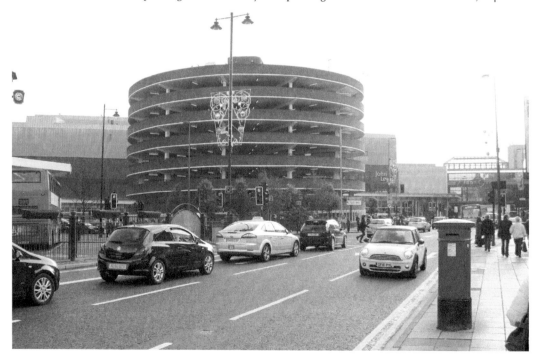

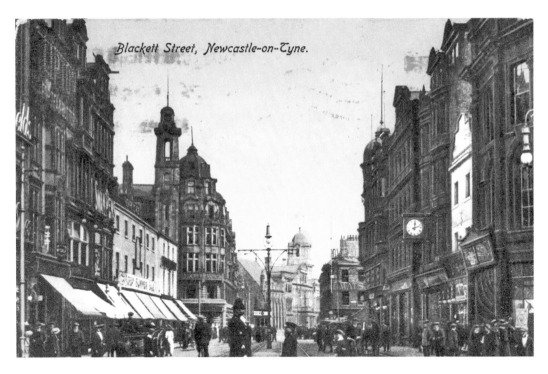

Blackett Street I

Blackett Street looking towards Northumberland Street. The street was built in 1824 and followed the line of the north section of the old town wall. Much of this area has been given over to pedestrians in recent years, although much is still open to buses and other service vehicles.

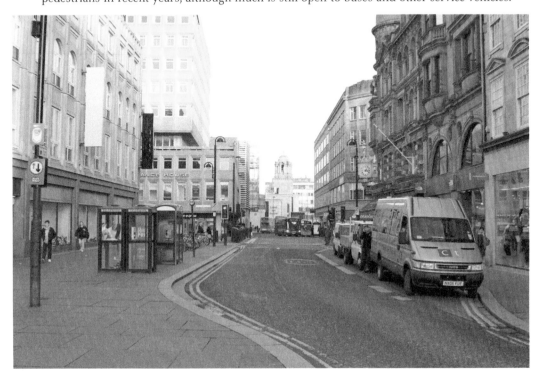

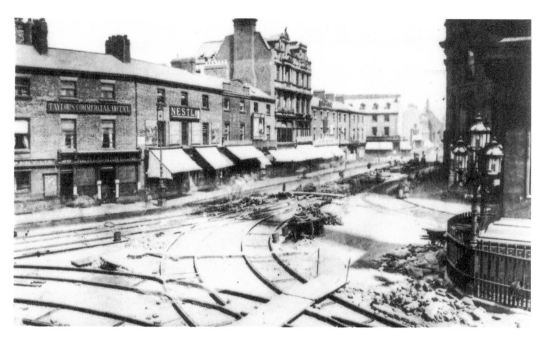

Blackett Street II
Blackett Street during the construction of the electric tram system *c.* 1900, and below around 2005 in its now largely pedestranised form.

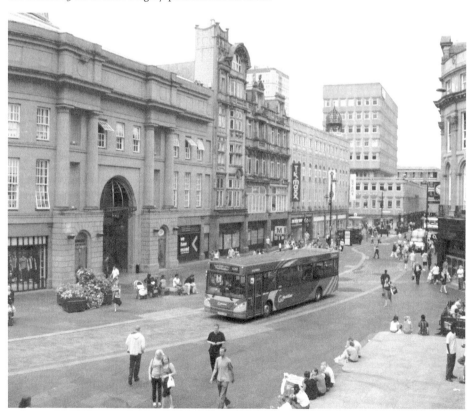

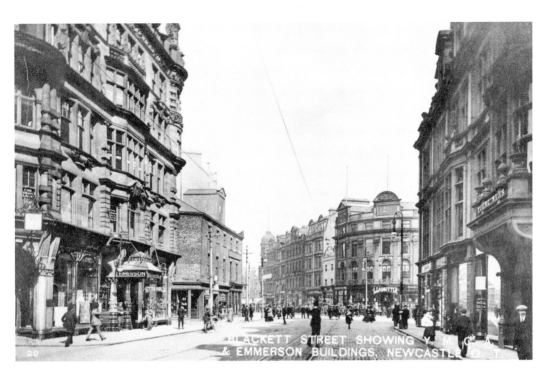

Emerson Chambers

One of the most impressive buildings on Blackett Street are the Emerson Chambers which are to the left of the picture and which survived the 'redevelopment' of the city in the 1960s and '70s. We can also see how years of coal burning have discoloured the fine frontages of the buildings. The YMCA building, visible to the right in the top image, was not so lucky and has been replaced by part of the new Eldon Square complex.

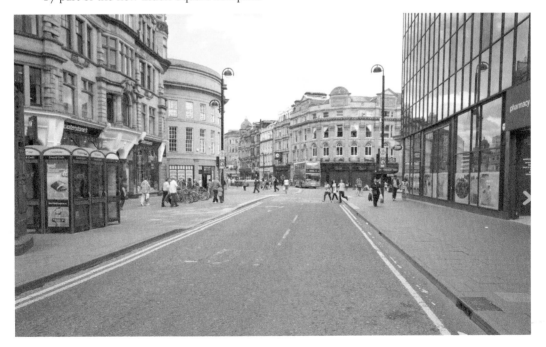

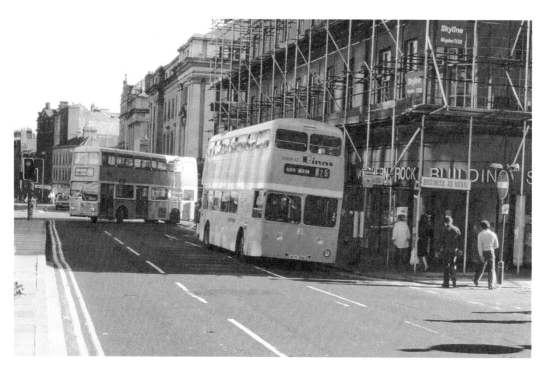

Pilgrim Street

The street's name is apparently derived from its use by pilgrims making their way to the pilgrim's gate in the city wall. The double-decker bus in the lower image is a high capacity Enviro 400 of which there are now many in the city due to strong passenger growth.

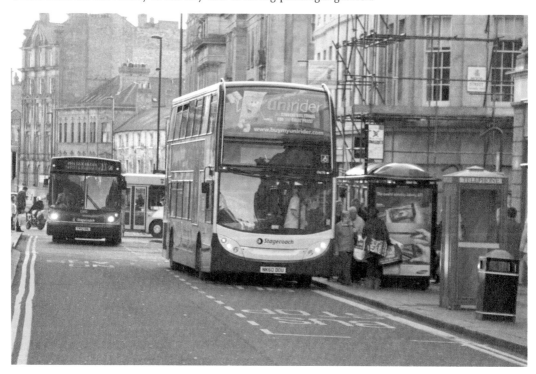

Blackett Street III

Above, buses and people on Blackett Street in the 1980s, and below around Christmas 2012. The latter image is one which it would again not be possible to reproduce today as the walkway it was taken from was lost during recent reconstruction of Eldon Square.

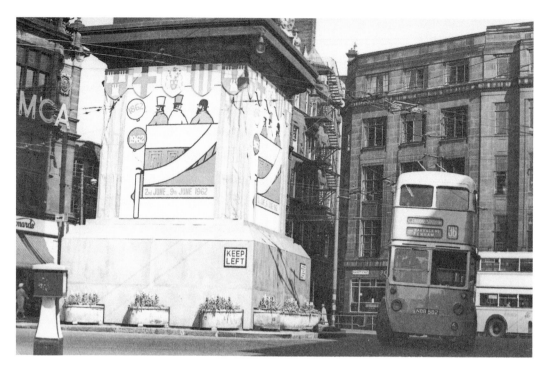

BUT

A BUT trolleybus rounds the Monument *en route* for Central Station. Returning as a No. 44, it will run through Fenham and make a large loop back to the city via Elswick Road, ultimately reaching Osborne Road. Today traffic has largely given way to pedestrians and public events. Long gone are the days when 'two threes and two halves' would buy a long strip of purple three ha'penny tickets from the conductor on the 36 and take a family of four from Fenham to the Toon. That's less than 4p in today's money!

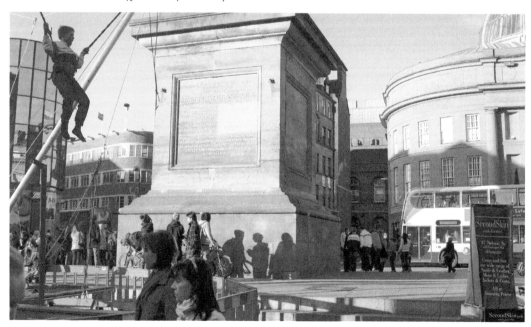

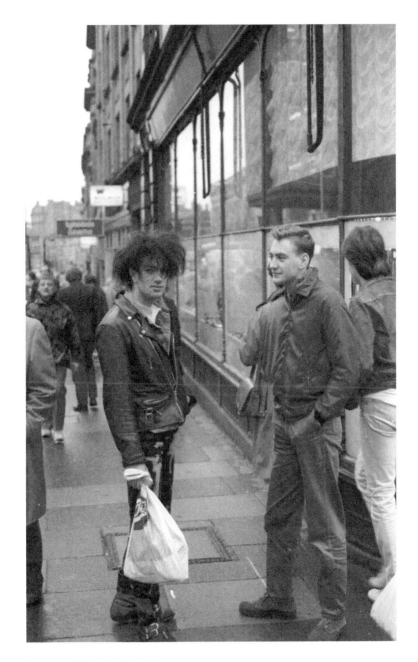

Corner of Pilgrim Street

Mike Affaz Atherfold and Neil Tweddell on the corner of Pilgrim Street and Blackett Street c. 1981. Mike studied Contemporary Photographic Practice at the University of Northumbria and is now active in media production in Salford. Neil moved to London and worked in retail. Both were members of Newcastle's alternative music scene in the 1980s.

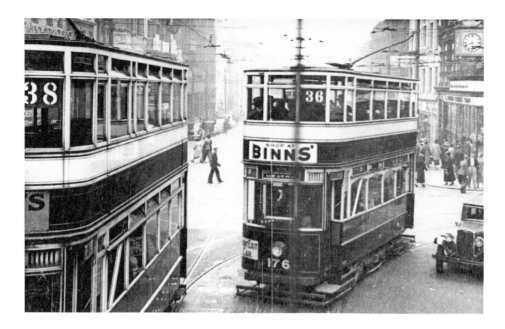

Trams

Trams of Classes B and G (No. 176) pass each other at the foot of Northumberland Street. Route 36 was a circular service to Heaton Road via Jesmond Road returning as a 37 via Shields Road to turn in the City via Pilgrim Street, St Nicholas and Grainger Street. The 38 is heading back to Central Station from Osborne Road. Newcastle built its last trams in the 1920s and these two types were relatively modern and draught-free compared with the rest of the fleet. Note the famous gold clock above Northern Goldsmiths, a well-used rendezvous point over the years. Below, the Tyneside PTE experimented for short while with a plainer livery for its buses, shown here on a Metrobus. Clearly visible under the windscreen is the PTE's logo, based on the River Tyne and the conurbations of Newcastle and South Shields which it served.

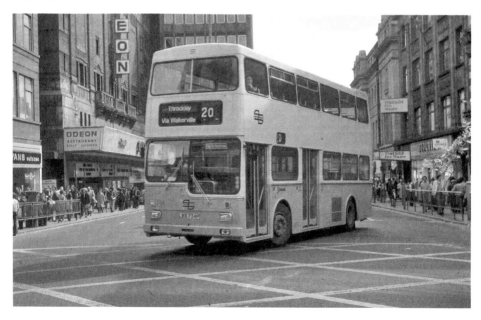

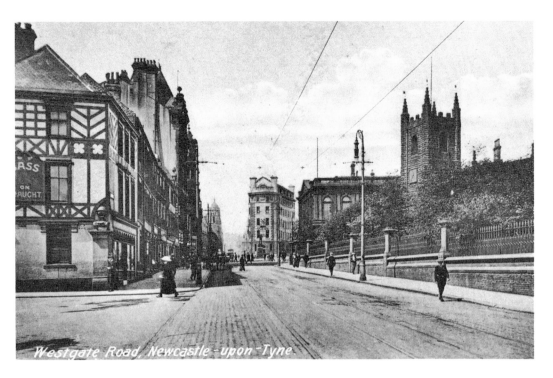

Westgate Road

Looking eastwards up Westgate Road. This short stretch of Westgate Road was the subject of some public discussion during planning for the 1901 extension of the tram system. Horse-drawn carriages parked here during services at St John's church and the narrowness of the road meant that something had to give! Eventually it was agreed that points would be incorporated in the tram tracks so that eastbound trams could switch to and from the opposite track at will.

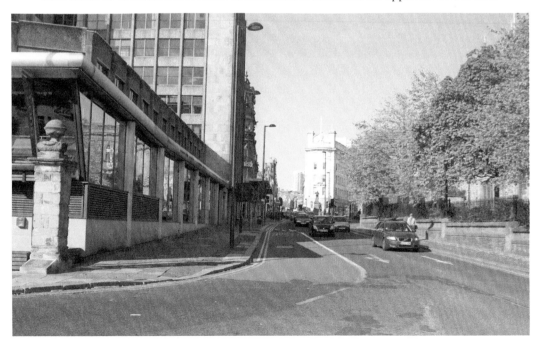

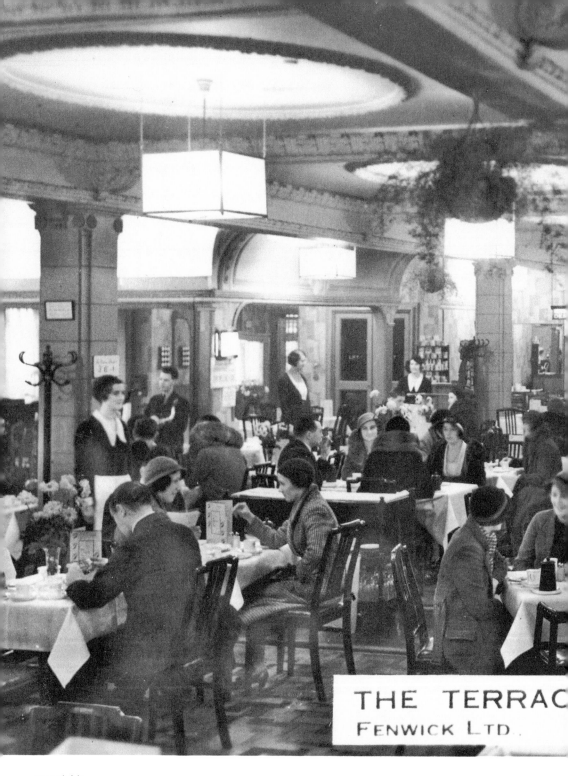

THE TERRAC

FENWICK LTD.

Fenwick's

The 'between the wars' interior of one of Fenwick's restaurants. We were unable to work out exactly where this was taken as the interior has been rebuilt several times over the years.

36

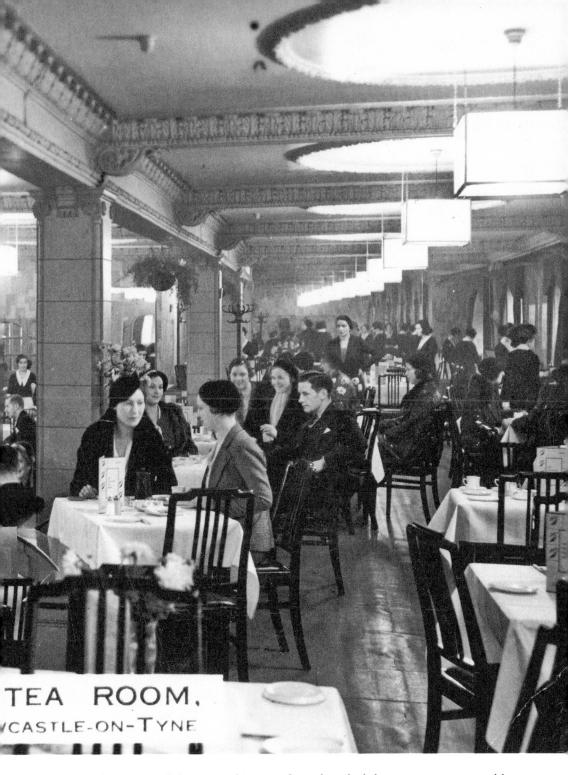

TEA ROOM,

/CASTLE-ON-TYNE

However, the reverse of the postcard it came from described the restaurant as a good happy place to meet friends with an excellent vantage point so we suspect it might be around the Northumberland Street side.

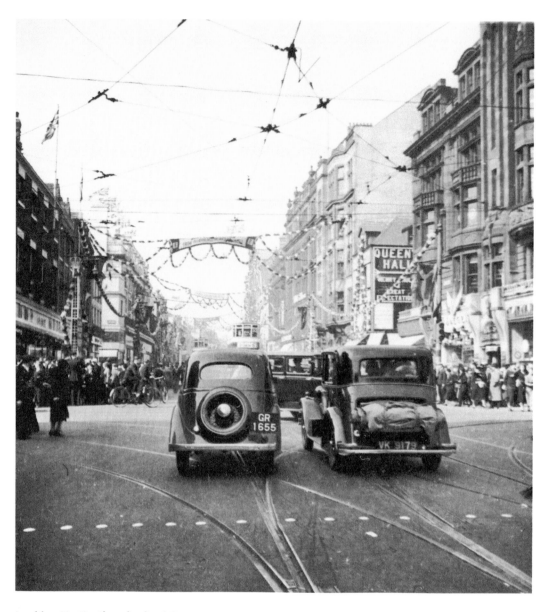

Looking Up Northumberland Street
It is suitably decked out to celebrate George V's Silver Jubilee on 6 May 1935. Presumably the bunting was put to good use again almost two years later to the day when George VI's Coronation took place.

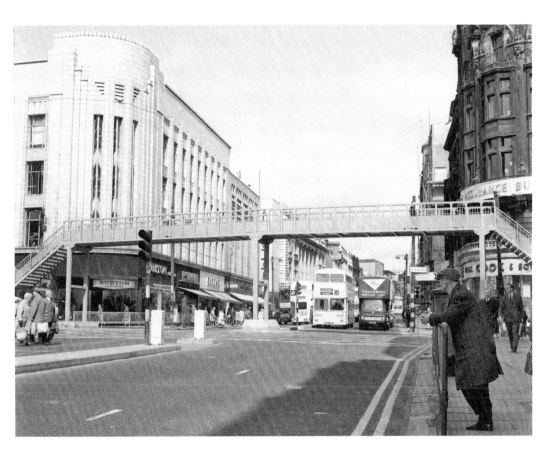

Northumberland Street I

It might be difficult for anyone under the age of thirty to recognise where in Newcastle this is, as almost all of the visible structures have been demolished. The building to the left is now the site of Monument Mall. The large footbridge is a reflection of the level of traffic that once flowed up Northumberland Street and the commuters that would have crossed into the city here, many coming in from Manors Station and the nearby Worswick Street bus station.

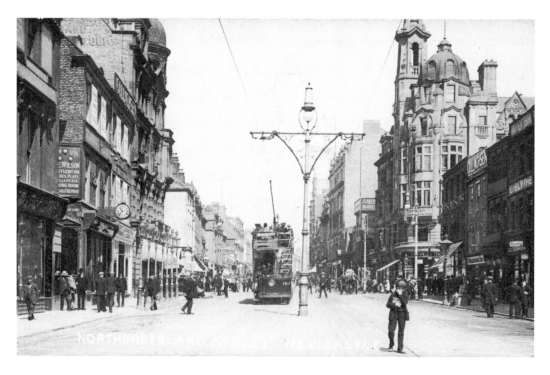

Northumberland Street II

A postcard view looking up Northumberland Street from Pilgrim Street. Postcards of this time often featured electric tramcars and lighting systems as they were status symbols for the city representing the height of modernity and progress. Overhead supports in the centre of the road became obstructions to traffic, although perhaps ironically the central reservation and lampposts have since returned. Again to the regret of many, several buildings visible in the upper image have since been demolished.

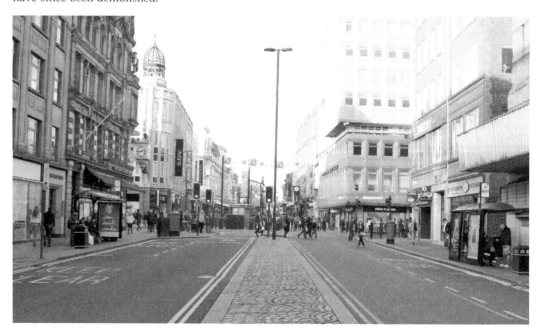

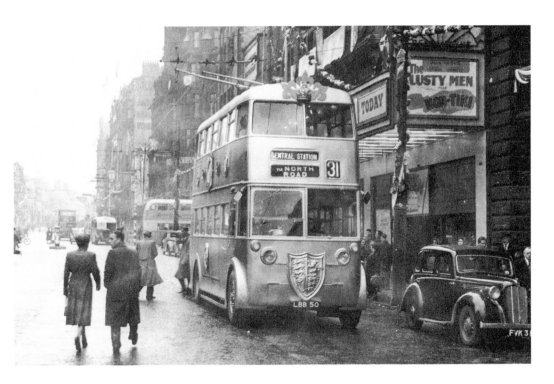

The Odeon

A Corporation trolleybus decorated for the 1953 Coronation outside the former 1931 Paramount American-style super cinema. At this point it was called the Odeon and was showing the 1952 movie *The Lusty Men* starring Susan Hayward and Robert Mitchum with the latter playing a rodeo hand who sustains an injury and is forced to return to his home town after many years of absence. We believe the cinema was listed, but later de-listed and then its interior was destroyed. Below, in 2012, it sits waiting a decision about its demolition and what future it or the site might have.

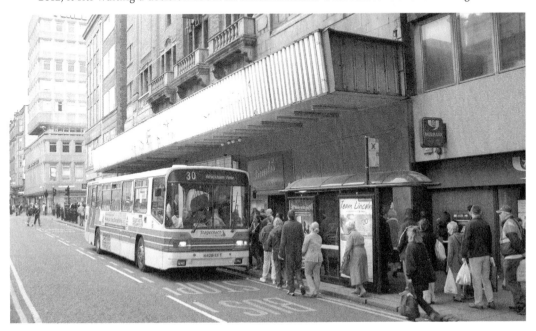

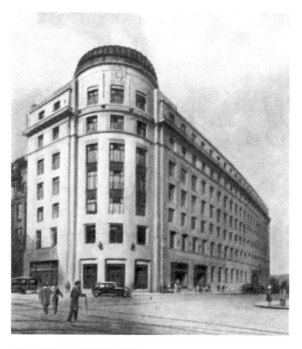

A Postcard View of Carliol House
Built in 1927 as the headquarters of the Newcastle-Upon-Tyne Electric Supply Company Limited, the Carliol House was designed by Mr Leonard J. Couves and Partners of Newcastle in association with Sir John Burnet and Partners. Around the time of opening the company supplied electricity to around 4,150 square miles. It is interesting to see it linked to the new Tyne Bridge in a contemporary advertisement as the construction of both would create welcome jobs during a period of economic difficulty and would stand as symbols of longed for future prosperity. The building is faced with Portland Stone and has been floodlit at night by 2,000 candle power. With the privatisation of electricity supply the building has changed use. What was once the groundfloor North-Eastern Electricity Board Showroom is now occupied by a fitness store. There are currently plans to redevelop and radically alter the area but the building's listed status should enable it to survive this.

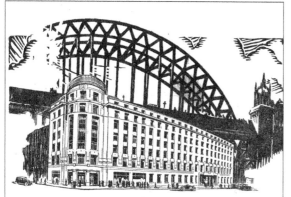

One Wonderful Structure leads to another !

Better Public Service ... the main object behind each of the two new super structures opened within one year in Pilgrim Street.

Eleven short months ago wonderful Carliol House entered with zest upon the gigantic task of Electrifying the North-East Coast area. Its efforts continue tirelessly to place its Electric Supply and Service still further beyond reproach.

A few hundred yards up Pilgrim Street from the New Tyne Bridge, Carliol House stands invitingly open to all. Come at least once a month—there is always something new to see.

Meet under the dome !

CARLIOL HOUSE
The Home of NES *Electric Service*
NEWCASTLE UPON-TYNE

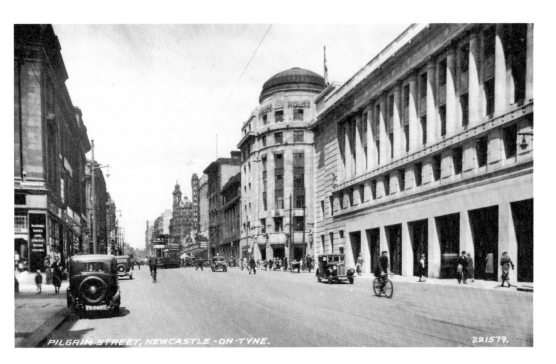

PILGRIM STREET, NEWCASTLE-ON-TYNE. 221579.

Pilgrim Street

In the 1960s and 1970s Newcastle councils seemed to have been quite enamoured with the idea of building over roads, possibly a reflection of the 'streets in the sky' philosophy. Now such buildings are slowly being demolished, but it would be interesting to see if their nostalgia value will increase. Possibly Carliol House and the combined police and fire station were also seen as more 'monstrosity' than 'magnificent' in their day.

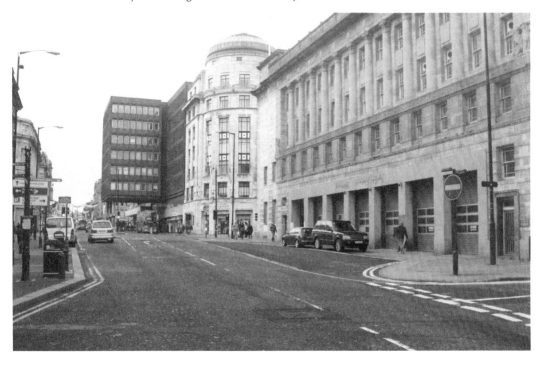

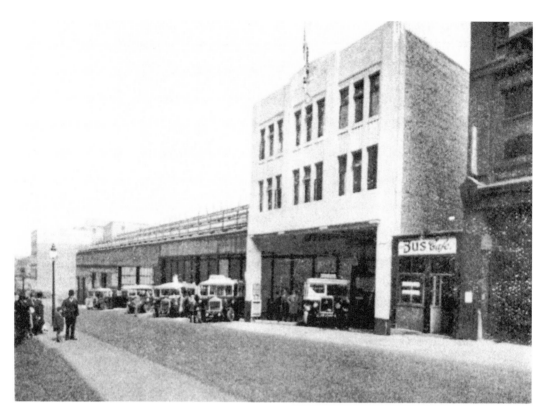

Worswick Street Bus Station I
Opened in 1929 in response to the opening of the toll-free Tyne Bridge, the bus station was for many years the point of departure for travellers returning to places such as South Shields.

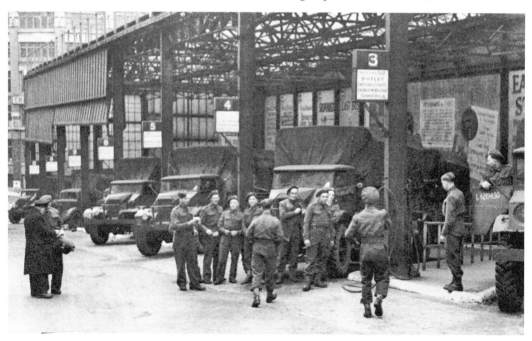

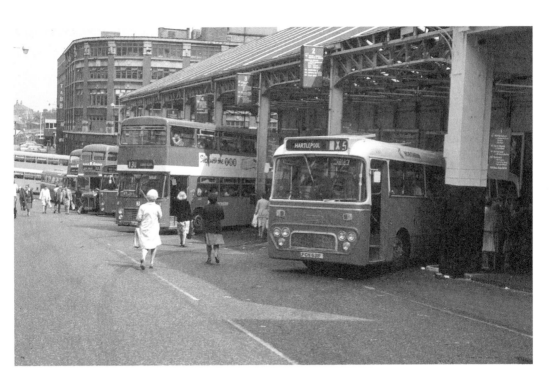

Worswick Street Bus Station II

While a bus station on a steep hill was perhaps not the greatest idea, Worswick Street was central and close to offices such as Carliol House, and slightly closer than the Central and Manors rail stations. Between 10 March 1949 and 23 March 1949 the Army ran a service during a strike by Northern Group Company's workers. The arrival of the integrated metro system in the '80s, however, meant that many bus routes no longer came into the city centre and Worswick Street's importance declined. We believe there have been proposals to reopen the station but modern low floor buses would have problems with the extreme incline of its platforms.

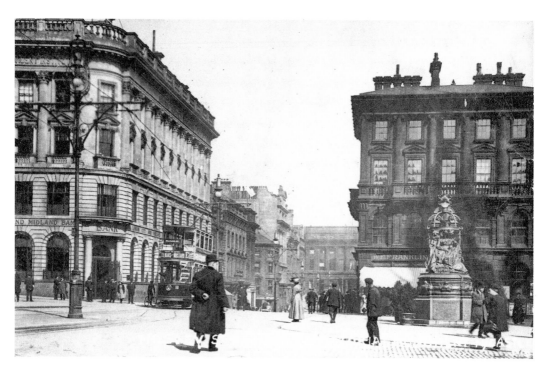

Looking Along Moseley Street

This is part of Newcastle's business district, although at night it sees many revellers making their way between the Bigg Market and the Quayside public houses. Apart from the people and the vehicles there are few alterations between the two scenes here.

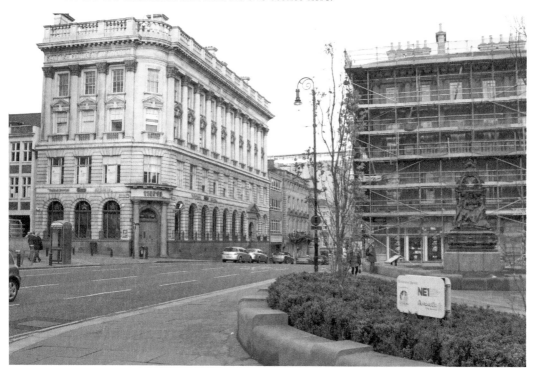

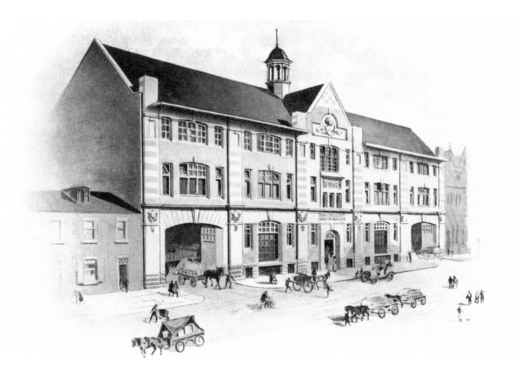

Stowell Street

Stowell Street is today famous for its many restaurants and is part of the city's flourishing Chinese District. It has long been a commercial area and this building, formerly a wholesale co-operative society, has been adapted well to its new use. The building in the line drawing is of course completely out of scale to the people around it. This was a common feature of such materials of the time.

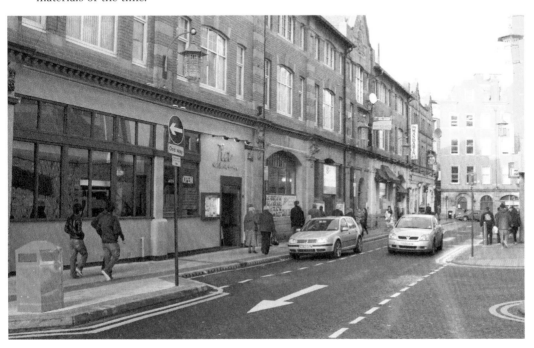

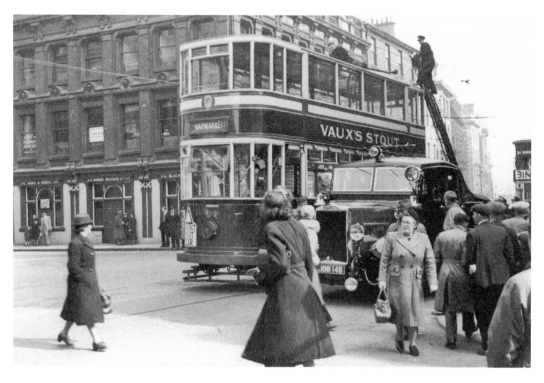

Detachment

A Gateshead & District Tramways tramcar has become detached from the overhead wire on Pilgrim Street and a man who we presume is the conductor seems to be using a fire engine to replace it. Presumably health and safety would have something to say about this practice now. Below, a Yellow Northern bus at a similar spot.

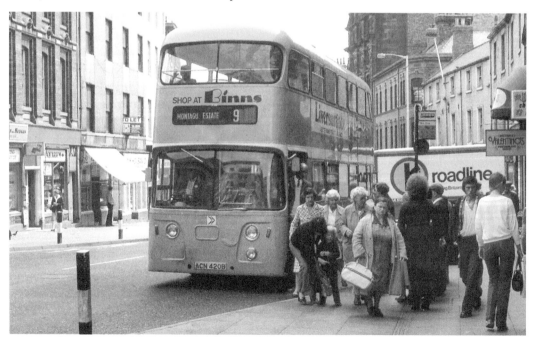

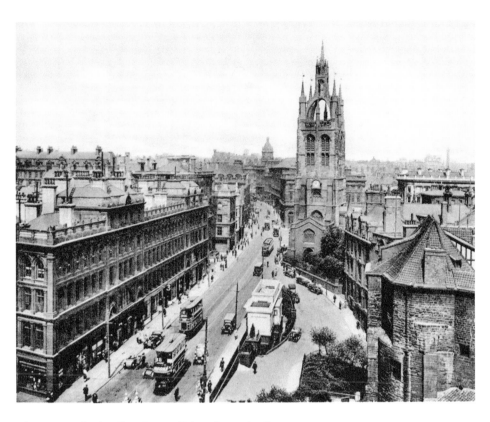

View Towards the City Centre Taken from the Keep

Along with demolition and changes to their exteriors, several buildings in the central area have been completely gutted and rebuilt.

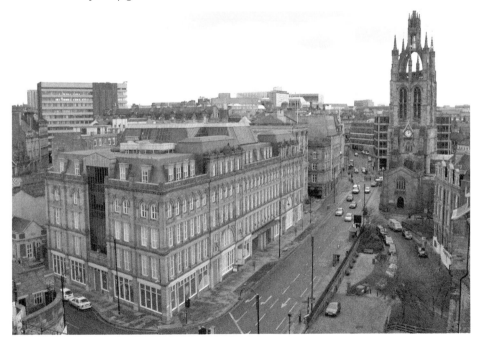

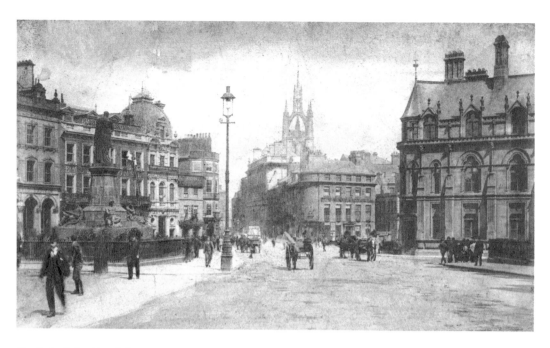

Capital of the North East

Looking straight ahead from Neville Street into Collingwood Street we can see prime examples of the fine buildings erected during Newcastle's nineteenth-century rebuilding as capital of the north-east. Thankfully buildings like these are still thriving all over the city, although many others were sadly removed in the 1960s and 1970s when their perceived value at the time was not sufficient to save them. The two open-topped trams are typical of the initial fleet, while a fine example is shown of the decorative but short-lived tram wire poles in the centre of the road.

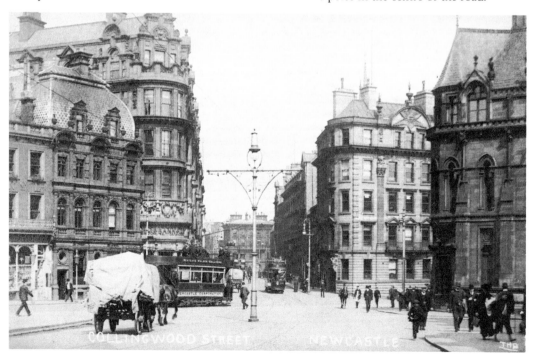

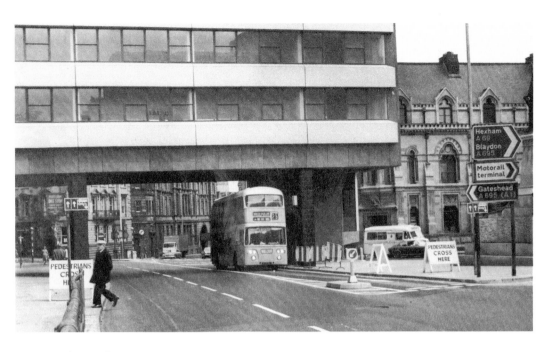

Stephenson's Monument

In this shot, Stephenson's monument creeps into view on the right. Unveiled on October 1862 it commemorates the life and works of George Stephenson who died in 1848. The four figures reclining on the corners of the plinth represent characters appropriate to the theme of the monument – a locomotive engineer, a plate-layer, a miner, and a blacksmith; each, like the miner with his Stephenson safety lamp, carrying tools and symbols of their trade. Occasionally during Rag Week one or more of these figures could be seen to be holding a Brown Ale bottle as well.

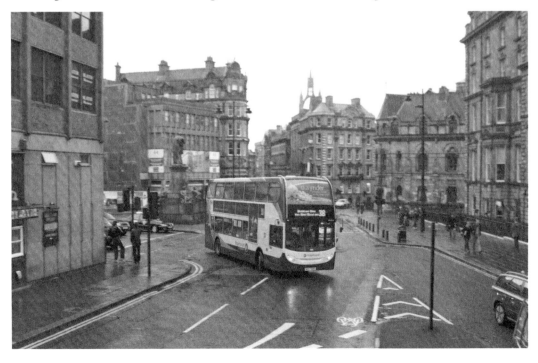

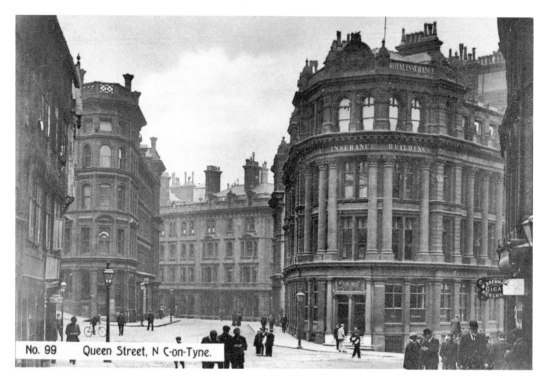

No. 99 Queen Street, N C-on-Tyne.

New Tyne Bridge

A true 'before and after' view if ever there was one! Initial plans for the New Tyne Bridge included a row of buildings constructed beneath it in this area, so that the bridge would seem to be resting on them. Thankfully that didn't come to pass, so this fine view of Queen Street has survived.

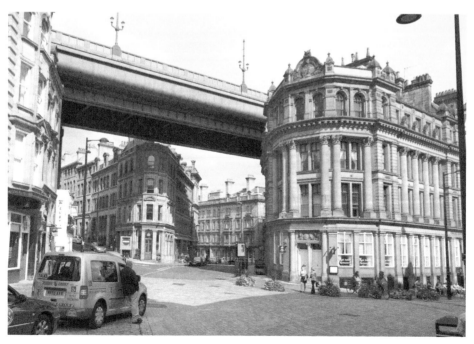

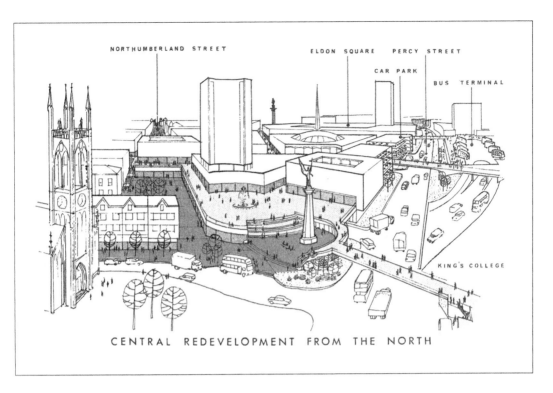

NORTHUMBERLAND STREET ELDON SQUARE PERCY STREET

CAR PARK

BUS TERMINAL

KING'S COLLEGE

CENTRAL REDEVELOPMENT FROM THE NORTH

Northumberland Street

There were radical proposals to redevelop Northumberland Street in the 1960s as shown here at the Haymarket end. Some of the proposals were implemented but many were not and we leave it to you to decide what was or would have been good or bad. Below this contemporary view of the area was taken from the University of Newcastle's Kingsgate building, itself a radically new building, but fortunately rather nice.

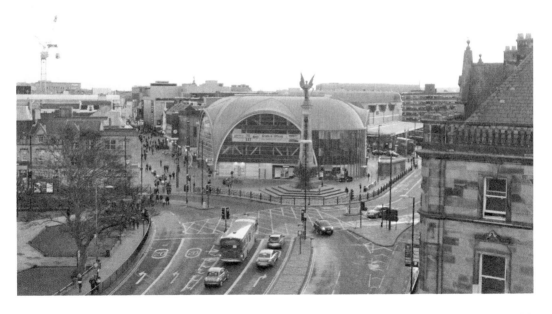

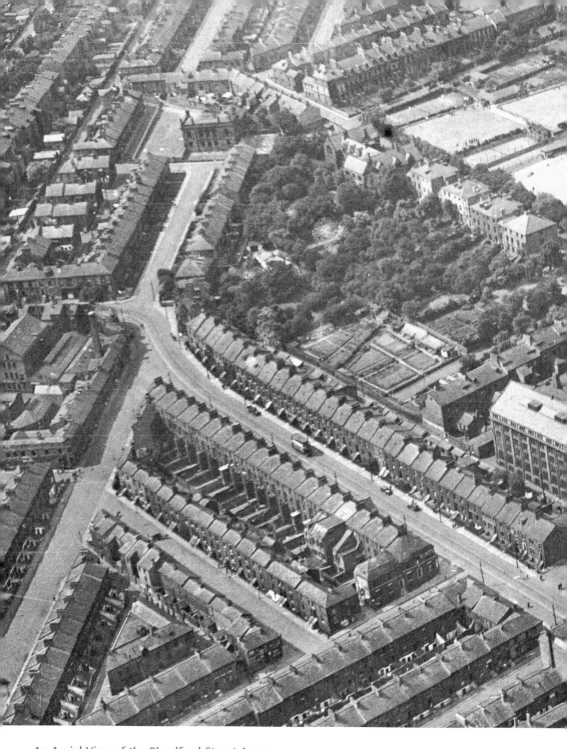

An Aerial View of the Blandford Street Area

Seen today it is remarkable how residential the district seems. Today much of the housing has gone either to be replaced by commercial use or simply disappeared under the surface of a road or a car park. To the right of the image stands the Co-operative Wholesale Society building of 1899 which was then the group's headquarters for the northern region.

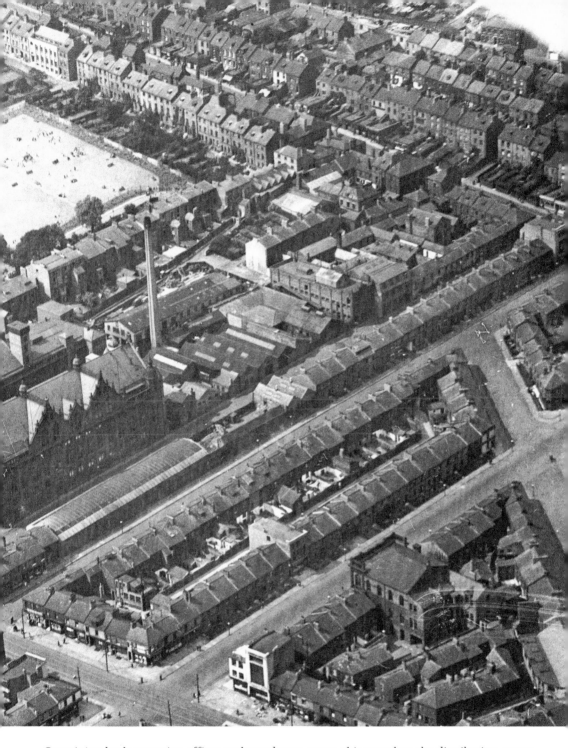

Containing both extensive offices and warehouse space, this was then the distribution centre for over 100 Co-op stores across the area. In 1978, the collection from the science museum in Exhibition Park was relocated here. Re-launched in 1993 as Discovery Museum, the museum has had ongoing development for many years including the 1994 transfer of *Turbinia* from Exhibition Park to the new glass-covered entrance at the Discovery.

Neville Street

Trolleybuses parked up on Neville Street. When Newcastle first introduced trolleybuses in the 1930s, they were large six-wheelers intended to cater for heavy peak-hour loadings on busy tram routes. After the Second World War, the final tram routes were replaced by trolleybus and motor bus services, which were extended to serve new housing estates in the outer suburbs. Smaller fifty-six-seat trolleybuses were deemed sufficient for these routes and three of them are seen here waiting to run out on the Benton Park Road (Nos 39 and 40) and Heaton Road (Nos 41 and 42) circulars.

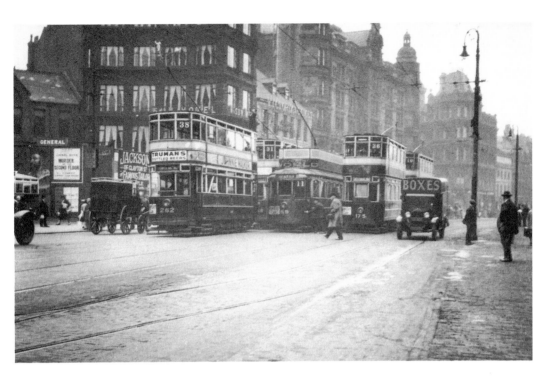

Trams in Neville Street Outside the Central Station

A tram towards the centre is one of the 'submarine' conversions of a single-deck car to double deck during the First World War, to give much needed extra capacity to the system. However, they did not last long after the declaration of peace. Neville Street looks relatively tranquil here and there have been proposals to limit access at the front of the station to taxis and buses only.

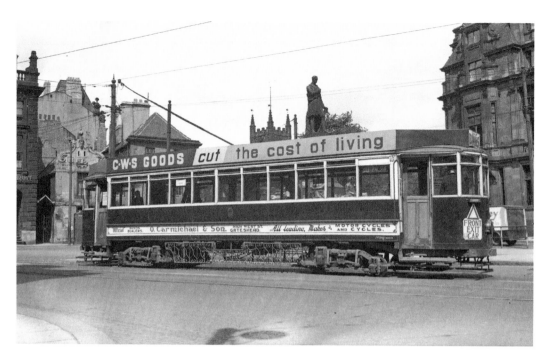

A Gateshead Tram Alongside the Statue of George Stephenson
Stephenson's Monument is facing the Literary and Philosophical Society and the Mining Institute. By the 1960s, the Northern Bus Company was the successor to the Gateshead and District Tramways Company and was operating national as well as local services. Below right is Mr Neil Tweddell and Mr Keith Mewton next to Stephenson's Monument.

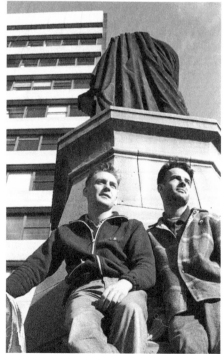

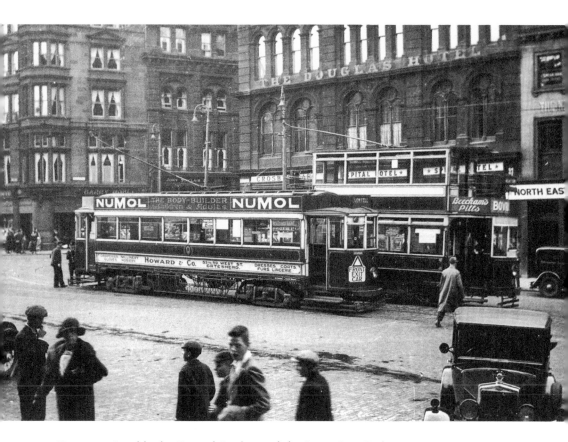

Tramcars Outside the Central Station and the Same Area Today
There have been plans to make this area bus and taxi access only, diverting private cars along Westgate Road, but this idea seems to have been shelved.

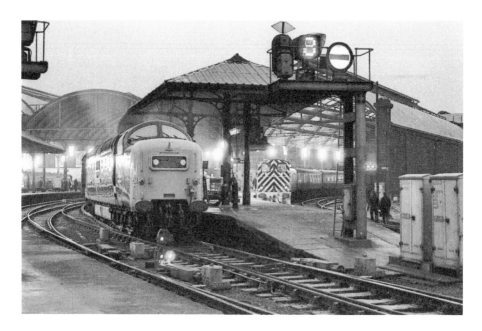

Deltic

With their 100-mph capability, the famous Deltic locos revolutionised services on the East Coast Main Line in the early 1960s. Twenty-two of them replaced fifty-five express steam locomotives – a portent of things to come. By 1967 steam had disappeared entirely from the North Eastern Region. Below, we believe the famous Hadrian Bar carriage was introduced in 1961 in the revised Tees-Tyne Pullman service between Newcastle and King's Cross. This famous and unique carriage is still in existence and has been used on rail tour charter specials.

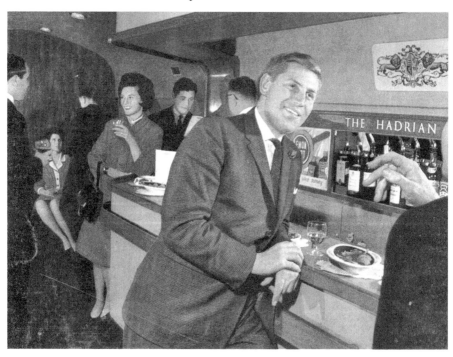

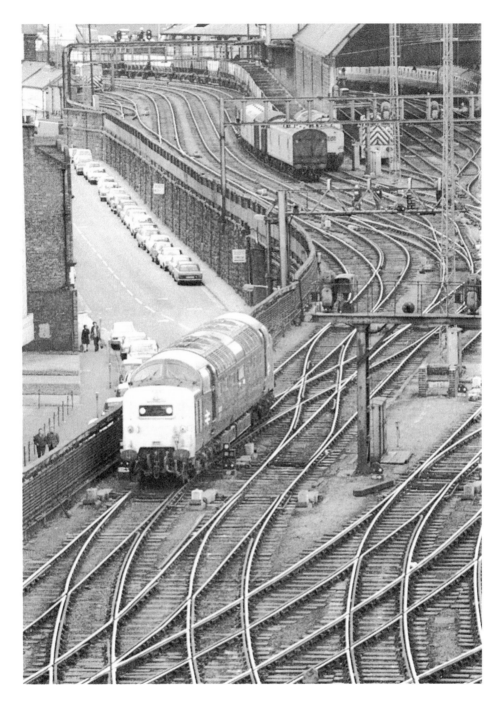

Central Station

Another Deltic threads its way through the goods lines at the east end of Central Station. Nicely shown here is the stone retaining wall along Forth Street, put in place when the site was levelled for station construction. The underground area between this wall and Neville Street is honeycombed with road tunnels and vaulted storage areas – covering a stretch of the old city wall! The area has seen massive redevelopment over the years – a process which seems set to continue.

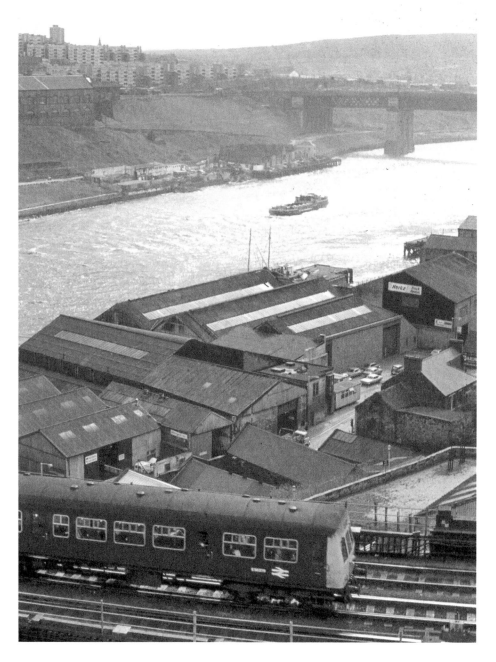

Rabbit Banks

A tranquil view across the Tyne from the Castle Keep to the south end of the King Edward Bridge, where it skirts the site of the old Gateshead engine sheds. The serene grassy area, known as 'Rabbit Banks' for some reason, was for many decades a scree-slope of ash and rubble, up which trainspotters would scramble to gain entry to the shed through its many broken windows. Those were the days!

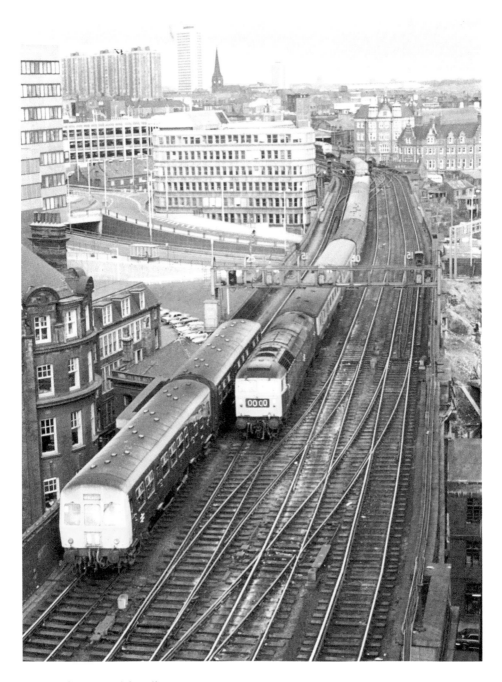

Newcastle & Berwick Railway

Taken from the Castle Keep, this shot belies the severe engineering challenges overcome when the Newcastle & Berwick Railway extended its line from Manors into the then new Newcastle Central Station in 1850. The line soared gracefully above Dean Street and merged with the main line from the south at the north end of the High Level Bridge before running into the Central. Originally only two tracks wide, the whole viaduct was widened in the late nineteenth century when a four-track section was created between the Central and Heaton Junction.

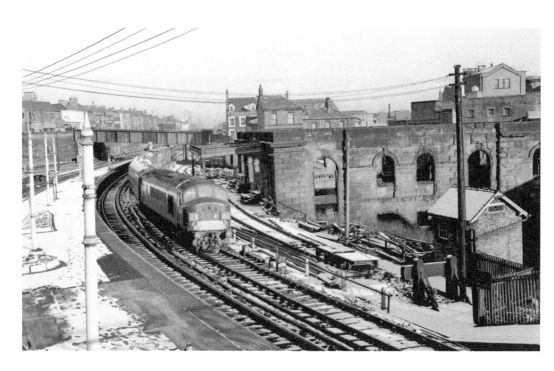

Pandon Dene Corn Warehouse

A wintery scene looking east from Manors station footbridge as a 'Peak' class diesel locomotive hauls a train towards Central Station. Clearly visible are the ruined remains of the old 'Pandon Dene Corn Warehouse' which dropped several storeys to the lower ground level. Although it survived the Second World War – just – it has since been demolished and this whole area is now unrecognisable and has since become the site of student flats.

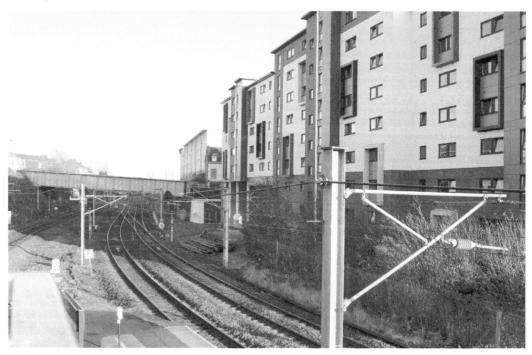

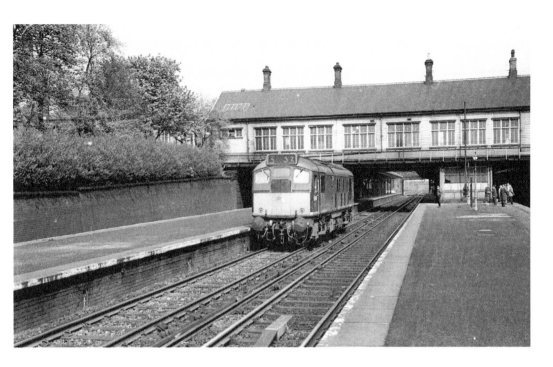

Heaton Station

Heaton station consisted of two island platforms serving the four tracks below, accessed by staircases from the wooden station buildings built onto the Heaton Road over-bridge. The station closed on 11 August 1980 when the Tyneside Metro opened on a route that more closely served the centre of Byker, and almost all evidence of Heaton's station has now gone as the image below shows.

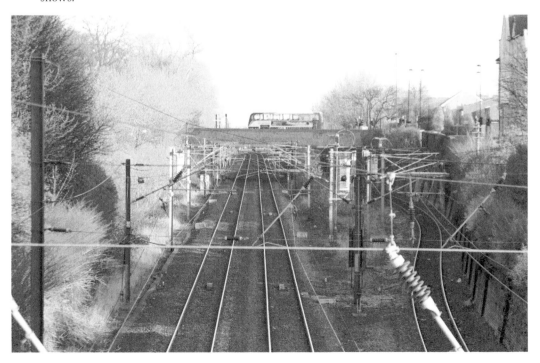

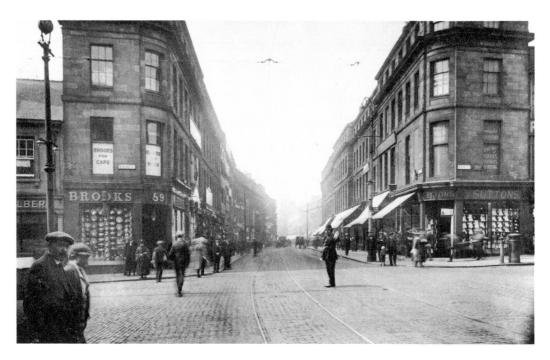

Clayton Street

These postcard and photograph views of Clayton Street's junction with Newgate Street can't have been taken many years apart judging by the signs and shop awnings. Note the lack of weather-proofing for the poor tram driver – most Newcastle trams were eventually provided with some form of windscreen, but some survived right to the end in 1950 with open platforms like these.

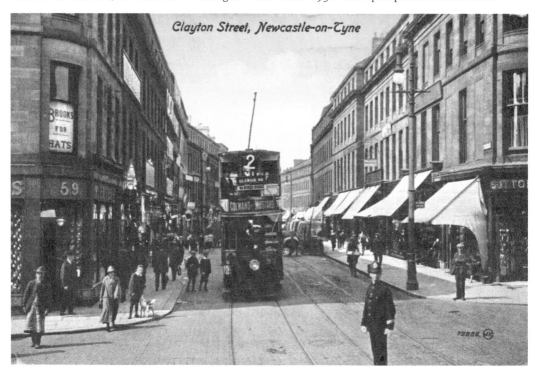

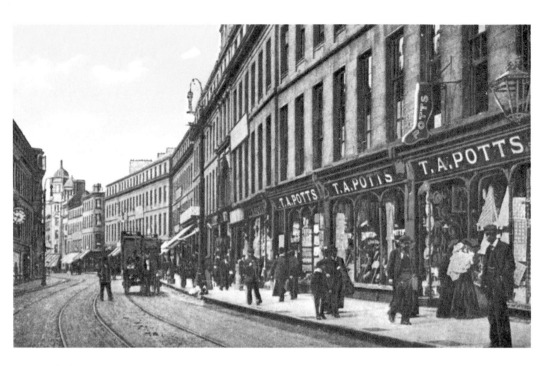

Rebuilding

Although examples of how much of the city was destroyed or damaged during the rebuilding of the 1960s and 1970s, these views of Clayton Street are a good example of how some streets in Newcastle have remained virtually untouched up to the present day.

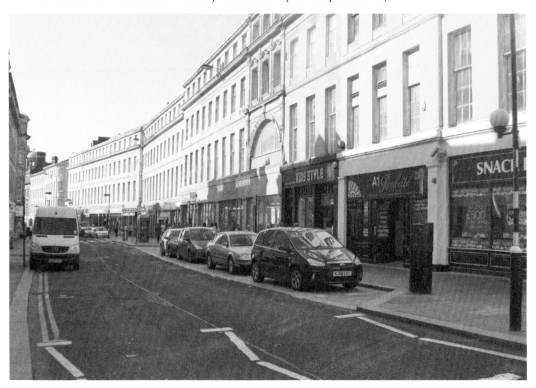

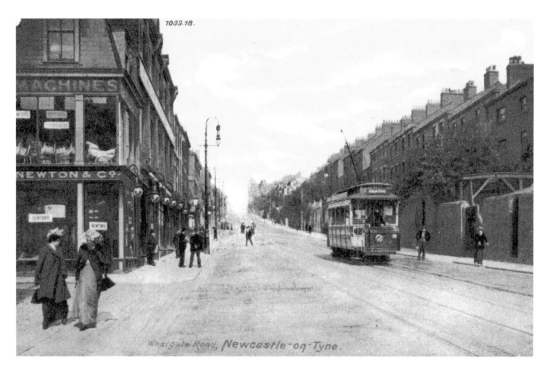

Westgate Hill

Sometimes comparative shots are very easy to take and this one showing the foot of Westgate Hill certainly was with a lot of change but some items remaining and the original vantage point still (just) available. The area was served successively by horse and electric trams (an experiment with steam haulage didn't last long!) then trolleybuses and now modern diesel buses. Again we see that many of the old buildings still survive.

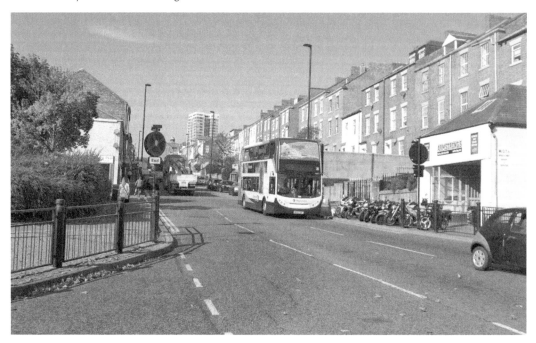

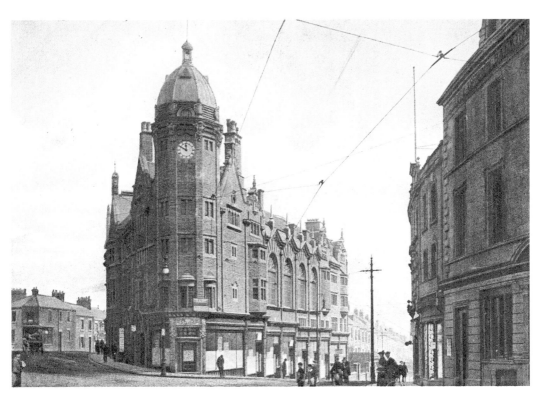

The Big Lamp
The junction of Westgate Road, Elswick Road and Buckingham Street will forever be known as 'the Big Lamp'. The source of this name lay in the mouth of Elswick Road, not far from the red traffic light.

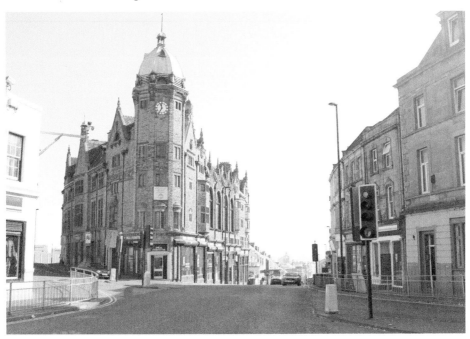

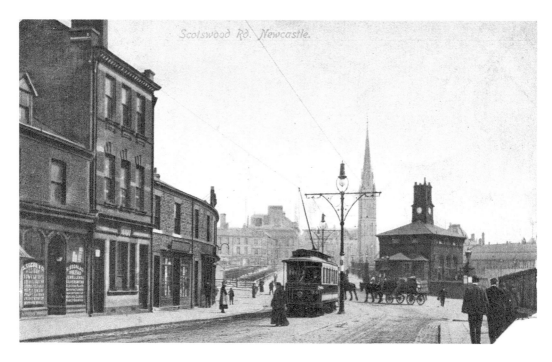

Scotswood Road

The end of Scotswood Road has seen many changes over the years. The cattle market and bus station, where many regulars at the Broken Doll public house waited for the last bus home, have been replaced by the Centre for Life and Newcastle's pink triangle has grown around the area. It was also the site of the World Headquarters' club and contains at least one excellent Iranian (or Persian) restaurant.

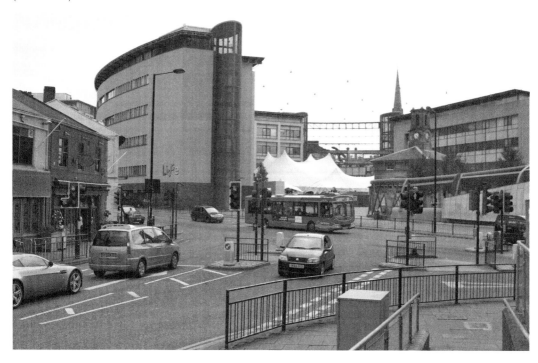

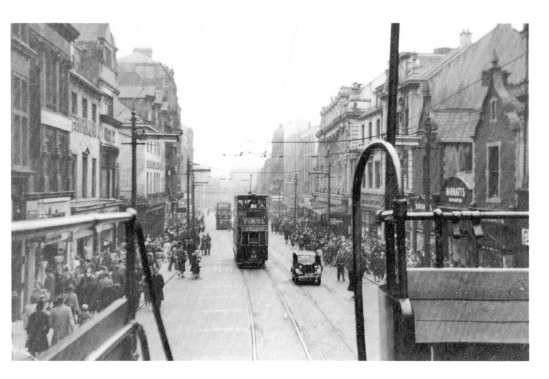

Newcastle's Premier Shopping Area

Although there have been many changes in Northumberland Street over the years, its place as Newcastle's premier shopping area has not altered. The above picture is taken from the top deck of a tram while the one below was obtained by standing on a Corporation bench.

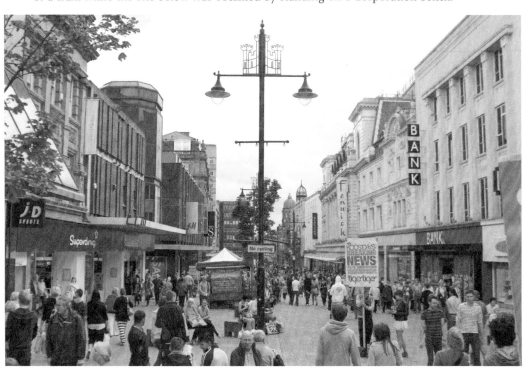

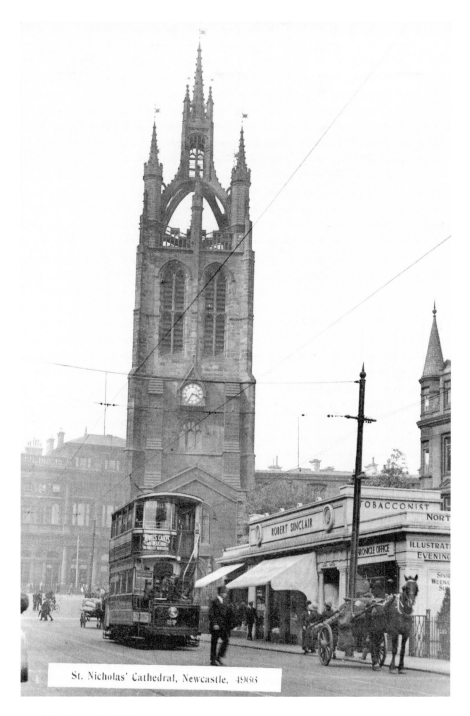

St. Nicholas' Cathedral, Newcastle. 4966

St Nicholas' Cathedral

The Cathedral is named after St Nicholas, the patron saint of sailors and boats. Appropriately, its spire contained a lantern which we believe was constructed in 1448 and it was long a navigation point of ships using the Tyne. It was originally a parish church, built in 1091, but this was destroyed in a fire in 1216. It was rebuilt in 1359 and became a Cathedral in 1882 when the Diocese of Newcastle was created by Queen Victoria.

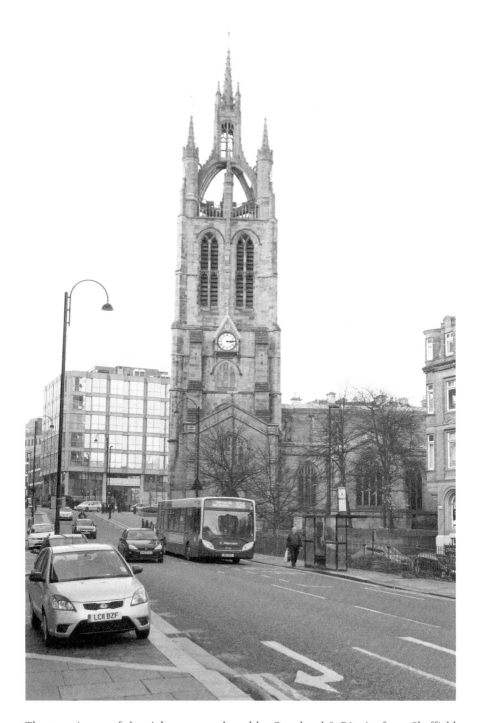

The tram is one of the eight cars purchased by Gateshead & District from Sheffield and placed in service between October 1922 and May 1924 in their Sheffield condition and livery as this one is. Between December 1925 and June 1926 they were all rebuilt as balcony cars with platform vestibules. In the modern picture the bus belongs to Stagecoach in South Shields and is being used on the x34 service to Horsley Hill Square.

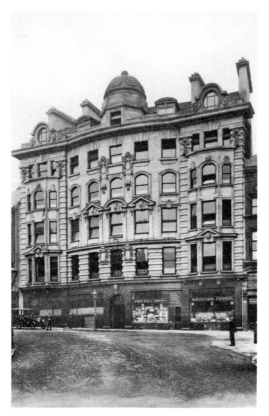

Akenside

The building known to many of today's
Quayside revellers as the Akenside is named
after Mark Akenside, a noted dentist and
poet. During a visit to Morpeth in 1738, he
had the idea for his didactic poem, 'The
Pleasures of the Imagination', which was
well received, and subsequently translated
into more than one foreign language. A
contemporary internet guide states that 'the
people that drink in here are mixed as it is
a very busy corporate area, but mainly the
mid-week crowd apart from the weekends
where the doors are open to everyone.
This is a pub that normally has a good deal
on some specials that you can get tucked
into to make the night better. I would
recommend after this pub if you are moving
into the Quayside go to Chase and if you are
heading up into town move on to Hoko 10
or The Living Room.'

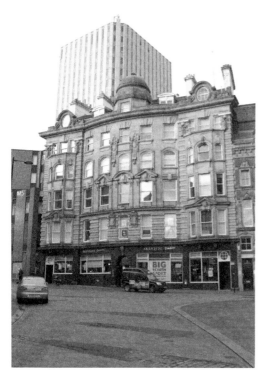

Swan House During and After Refurbishment

Swan House was built by the Post Office in the mid-1960s. The site had been occupied by Grainger's Royal Arcade, a shopping development from the previous century that never really took off. Swan House was built when a home telephone was still a relatively new arrival in many houses. Getting a telephone installed involved filling in several forms and then waiting for several months until someone from the General Post Office arrived at your house in a van and hard wired a telephone into your property. The post office tower was opened in the 1960s and telephone calls that were transmitted via satellite and international dialling were new and exciting services. Perhaps ironically, there was also talk of video phones although this is something that more than forty years later has never really taken off, discounting services such as Skype and services offered over the internet.

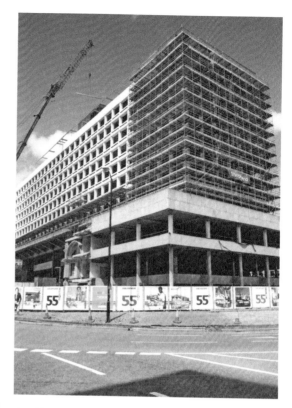

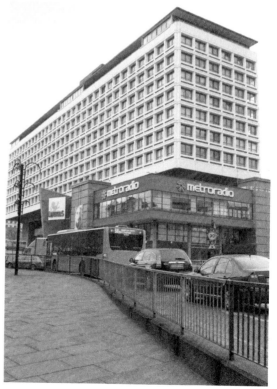

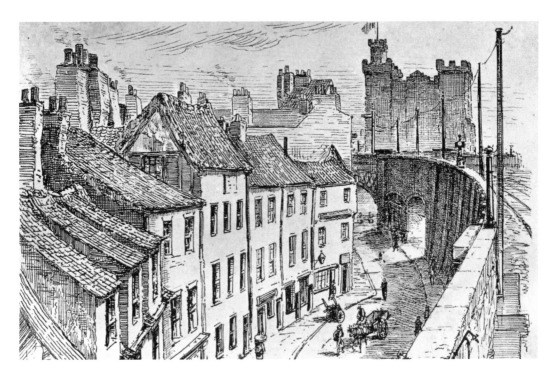

The Keep
The castle area seen from the grounds of the Central Station. It is amazing to consider how the railway, which now runs to Edinburgh, was just driven through this historic site. However, the castle keep does make a fantastic place from which to photograph trains.

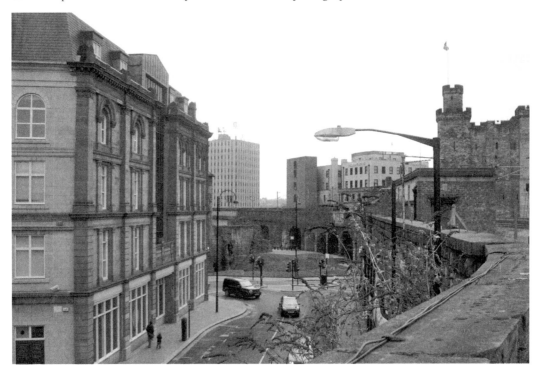

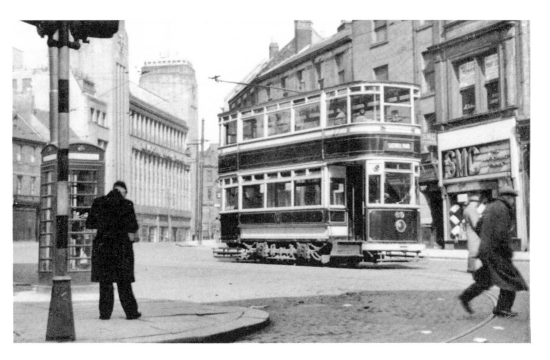

Newgate Street

A Gateshead tram heads down Newgate Street for the High Level Bridge and the road home. The famous art deco Co-operative building in the background is set to enjoy a new lease of life as a hotel and leisure complex. A similar scene, *c.* 1980, shows that much of this area has since been changed utterly in further redevelopment of Eldon Square.

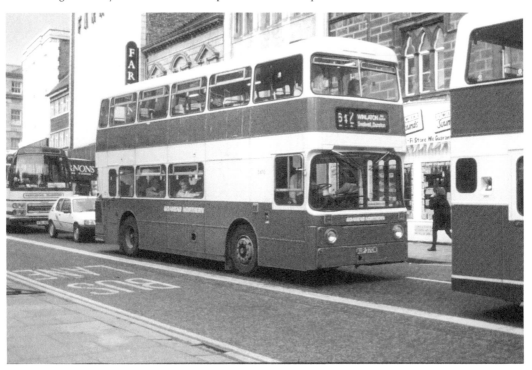

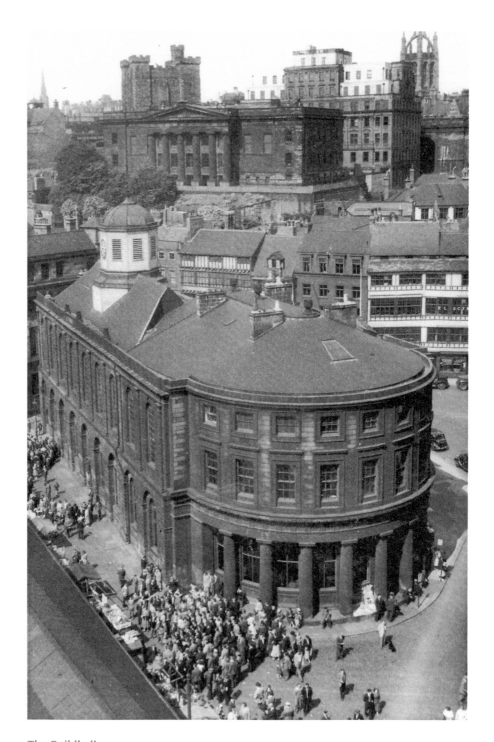

The Guildhall

The magnificent Guildhall on Newcastle Quayside. It is one of many of Newcastle's historic buildings which shows the accumulated grime of industrial air pollution as well as a certain amount of neglect. The Guildhall was the centre of town government and social life. It was there that the courts met, where the guilds held their meetings

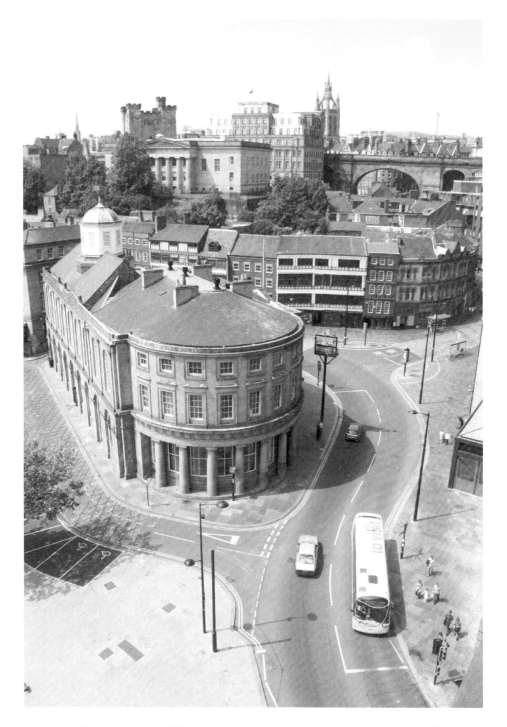

and where banquets were held. During the 1984–85 miners' strike, the industrial band test department performed a benefit gig for miners' wives in the Guildhall and it was also used as changing facilities for the 1988 movie *Stormy Monday*. It has also seen use as a tourist information centre. However, today it is one of the few buildings on the city's bustling scene to not actually be a pub, a club, a restaurant or an apartment block.

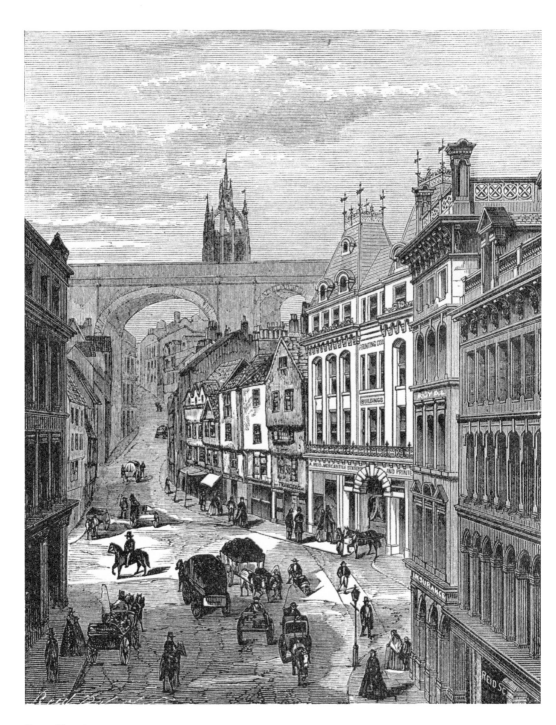

Dean Street

The Dean Street and Side area from an 1889 town guide. The same guide commented that 'Proceeding down the Side from St Nicholas Church towards the Sandhill we come to a railway arch which carries from the central station the northern and eastern traffic of the North Eastern Railway. It is one of the finest elliptical arches in the world. Let the stranger having gone under it

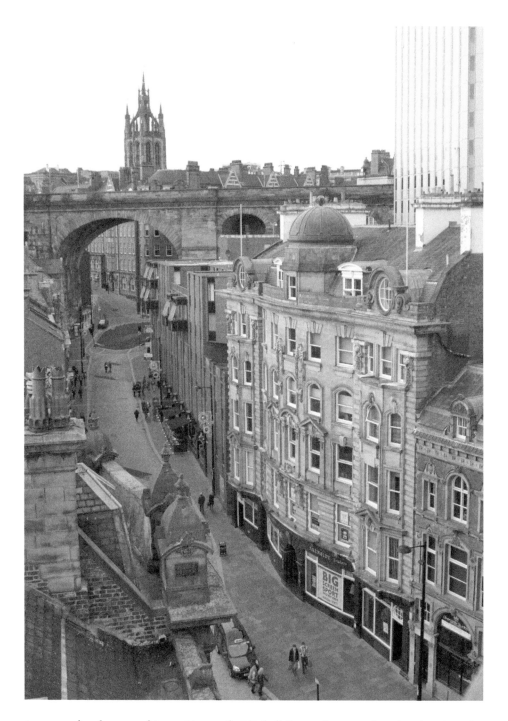

turn round and arrange his position so that it shall form a framework embracing the spire of St Nicholas and the old houses of the side.' Unfortunately, it was not possible to take the now picture from the exact same place as the drawing was produced from. We used the Tyne Bridge instead. We did try ringing some doorbells in Queen Street but only received one mumbled reply before being politely requested to 'go away'.

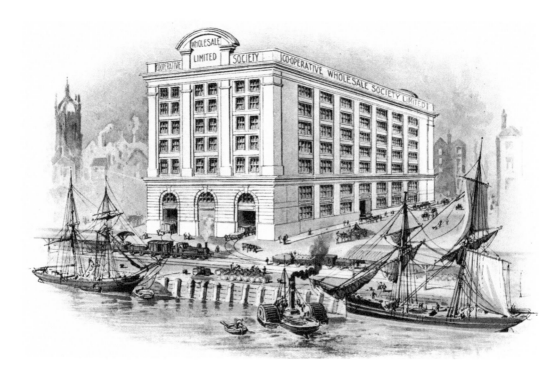

Co-operative Wholesale Society

The imposing Co-operative Wholesale Society building on the Quayside is quite a relic. Built as a bonded warehouse in the 1890s, it was one of the earliest reinforced (with mild steel bars) concrete structures in the country. It now houses the Malmaison Hotel. The word Wholesale on the building's frontage was removed during its reconstruction. A similar railway warehouse building in Forth Banks is to be incorporated into Northumbria Police's new police station for Newcastle.

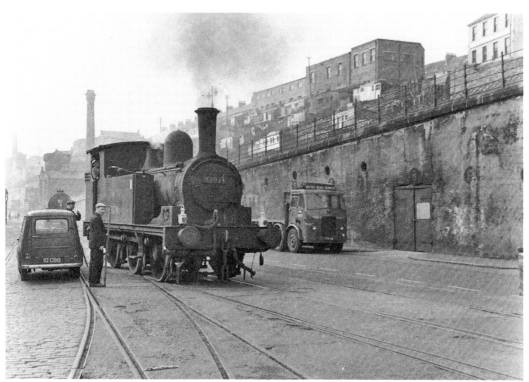

Quayside

Prior to the 1900s Newcastle Quayside was associated with shipping and commerce. Today it is more associated with pubs and restaurants. Although the Corporation owned the railway lines and sidings on the Quayside, for many years British Railways provided shunting locomotives to move rail vehicles around the warehouses and crane locations. Looks like the Austin A35 van driver has parked a little too close for comfort!

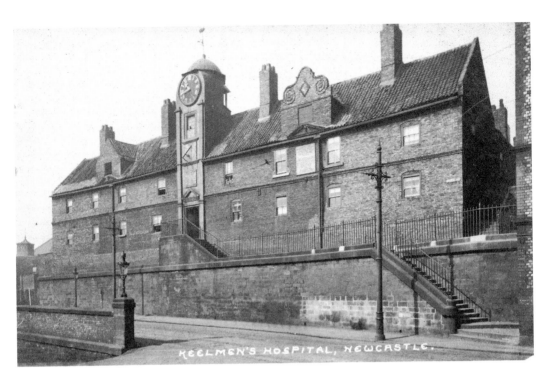

Keelmen's Hospital on City Road

The alms-houses paid for and built in 1701 to house the poor and aged Keelmen. This was another of the city's historic buildings that suffered some neglect in the middle of the last century but it has since been restored and we believe the structure is now in use as accommodation for students of Northumbria University.

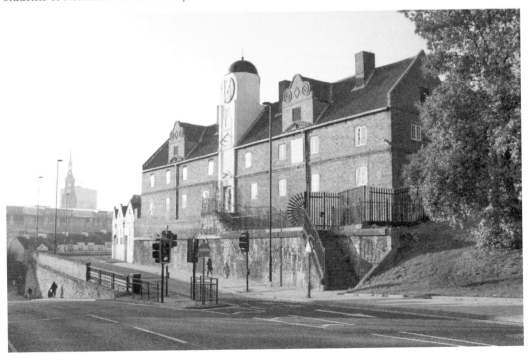

Newcastle Memories by Hugh McAulay

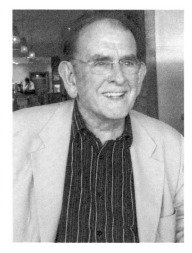

In the winter of 1941/42 there were extremely heavy falls of snow and my parents had planned to go up to Glasgow, my mother's home city, for Christmas. My parent's bungalow was in Coldstream Road, off Denton Bank, and normally we would have got the No. 4B trolleybus to Cowens Monument for the Central Station. However, we had to walk in single file up the middle of the West Road between banks of snow, and I remember being fascinated by the roofs of one or two cars sticking up through the snow. We had to walk all the way to Wingrove Depot, near the General Hospital, from where a service of trolleybuses was running only as far as the Big Lamp at the top of Westgate Hill, as they were not prepared to risk running down the steep gradient of Westgate Hill. We had to walk the remainder of the distance to Central Station.

I don't know what the situation was in other parts of the city but I do remember two tank traps in the West End. These were concrete blocks which partially restricted the movement of traffic by only allowing one direction at a time, the idea being they would hopefully slow down any invading enemy tanks. I now wonder just how effective they would have been. There was one on the West Road, just east of Wingrove Road, near the General Hospital, and the other one was on Denton Road, between the West Road and the foot of Whickham View. Why Denton Road is a mystery as it was not exactly a main road in or out of the city.

My mother had registered our ration books during the Second World War with the Newcastle upon Tyne Co-operative Society's shops at the Benwell Lane/Delaval Road junction, the terminus of the Elswick Road trams. As a result I was along there regularly with my mother and clearly remember the trams which were converted to trolleybuses in June 1944. There was a young man, probably late teens or early twenties, who struck me, even as a child, as not being quite right. He spent all his time at the tram terminus chatting to the tram crews and swinging the trolley pole to save the conductor the bother. An Aunt, who lived a short distance down Whickham View from Delaval Road terminus, told me that this man was at the terminus in all weathers, but he was not seen again after the trams came off.

Quite often on a Sunday morning after church – John Knox Presbyterian Church on Elswick Road at Beechgrove Road – we would take the Elswick Road trolleybus down to Grainger Street and walk down to the Quayside to see the Sunday Market. To a small boy this was absolutely fascinating as for a start there was the swing bridge which my Dad would take me to look at, then there was the various stalls themselves selling all kinds of things. We usually had an ice cream if the weather was warm enough, but it was how we got home that could be interesting.

Sometimes when we had walked the length of all the stalls, we would walk up onto City Road and wait ages for what seemed to be an infrequent No. 4 trolleybus home. Other times we walked back along the Quayside and then used one of the two very large lifts that went up the insides of the towers that supported the Tyne Bridge. I did hear that in October 1966, when the trolleybuses finally finished, on the Sunday morning after the closure, the lift refused to operate until it was discovered that they were wired into the current supply system of the trolleybus network. When that had been shut off on the previous Saturday night that was the end of the lift's power supply.

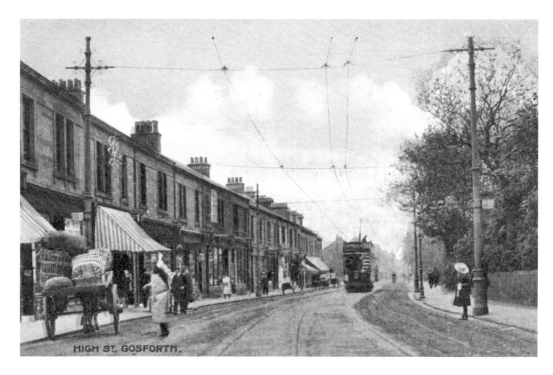

Gosforth High Street I

An interesting postcard showing Gosforth High Street before the First World War. When Newcastle Corporation electrified the Gosforth tram service as far as its then terminus at Henry Street, it had to run power feeder cables for the route from the city centre, there being no outlying substation at the time. Usually such cables ran underground to the sections they fed, but on occasion they were strung up alongside the tram wires themselves. Hence this view which seems to indicate trams one side, trolleybuses the other!

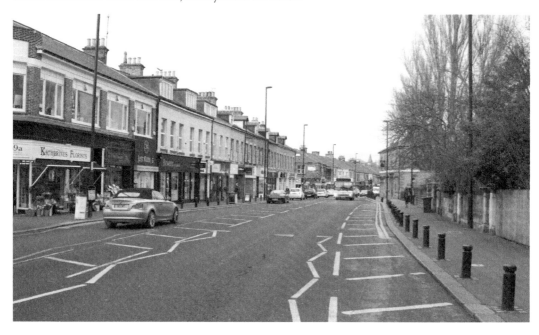

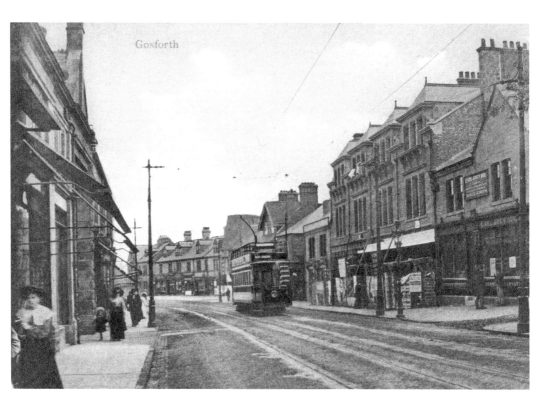

Gosforth High Street II

A little further north, near Gosforth High Street's junction with Church Road. A classical (for the time) open-platform, open-top tram is heading for Newcastle. Nowadays this is a busy area and was often used by the staff of Northern Rock – now Virgin Money – as a watering hole.

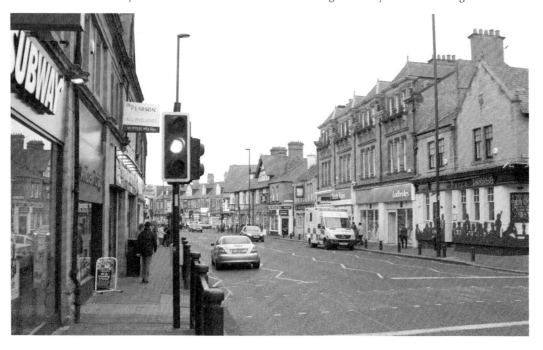

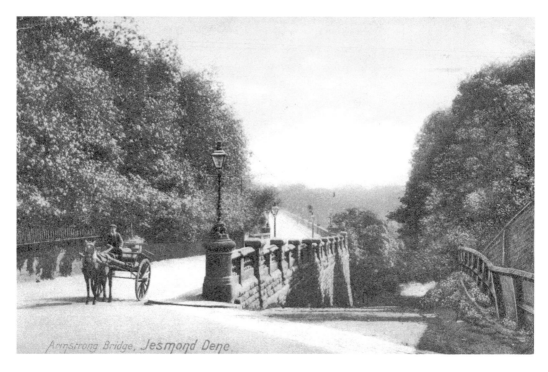

Armstrong Bridge, Jesmond Dene.

Armstrong Bridge

Between the dates of these two shots at the western end of Armstrong Bridge, the trams and trolleybuses came and went! How exciting it must have been to feel the tram tipping forward as it began the descent of Benton Bank, perhaps picking up a little extra speed prior to its ascent from Jesmond Dene on the other side. Worth a penny fare just for the experience! Today's view shows a once-busy trunk route out of the city reduced to parking and access only...

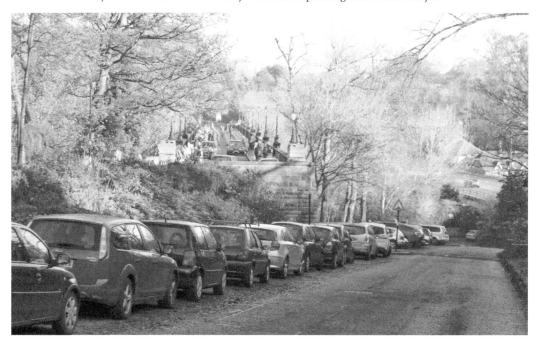

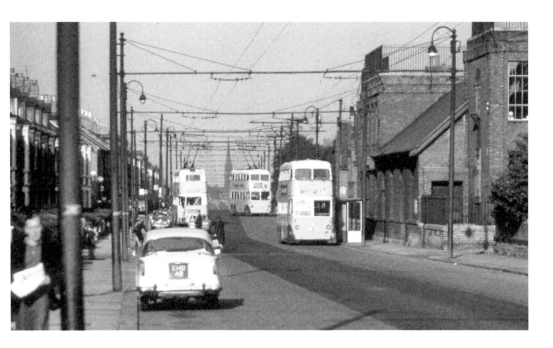

Trolleybuses

A once common sight on the 34 and 35 trolleybus routes running west to east right across the city. When the original tram services were replaced by trolleybuses in 1935–37, use was made of the existing kerbside poles. However, the weight of the additional overhead wiring necessitated some strengthening of the structures, and this was the result. Not pretty, but effective, and it survived in this form to the end of the system in 1966.

Newcastle Memories by Anthony Fox

I remember living a stone's throw from Slatyford Lane Bus Depot when it opened in 1956, having watched its gestation from the gaunt steel frame which had stood untouched for several years. I lay in bed listening to trolleybuses and the Atlantian buses charging along Silver Lonnen on their empty runs back to the depot. We used the trolleybuses to get to all home matches, reserves as well at times, always at the Leazes End. My Grandfather was the instigator of a lifelong interest in Newcastle's history and transport. He dragged me all over the city and how I wish he were still around to listen to, and pose questions I never thought to ask him at the time. He also let me share in his rabbit keeping and showing, and many's the time I've struggled up the bank from Jesmond Vale with a sack of dandelion roots (oh yes!) to feed the little beggars. Weekends were often taken up travelling to shows around rural Northumberland on United buses, with rabbits in their boxes. Memories from trips to the town are hearing the cry of the 'carrier bag' lady (brown paper and string, not plastic) when crossing Clayton Street from Green Market to the Grainger Market and the massed flower displays at the Newgate Street end of the Green Market. Sometimes I would scrounge cut-off cauliflower leaves in bulk 'for the rabbits', often with a knowing glance from the greengrocer telling me that he/she thought they were for human consumption! Then on Sundays my Father, who dealt in commercial flooring, would take us for a trip out down to Walker or Wallsend where he checked out the work his lads were doing in the fitting-out and refit yards. Sitting in his van downwind of the boneyard for an hour or so is not such a good memory. His office was near the Royal Grammar and on occasions he'd bring home a cricket ball or two which had come over the fence. Must write a book about this some day!

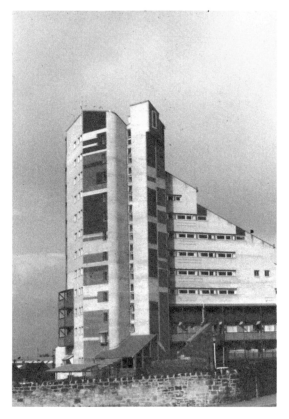

The Slightly Altered Face of Byker Wall
The Wall is a mid-1970s housing estate designed by architect Ralph Erskine assisted by Vernon Grace. The style has been described as Functionalist Romantic. Although an existing estate was demolished to make way for the wall, many of the public buildings were retained to encourage social continuity. Recently, much of the estate has been refurbished. The Wall has been placed on UNESCO's list of outstanding twentieth-century structures and since 2007 it has been a Grade II* listed building.

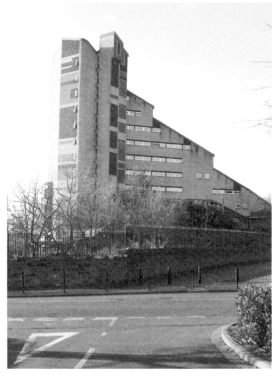

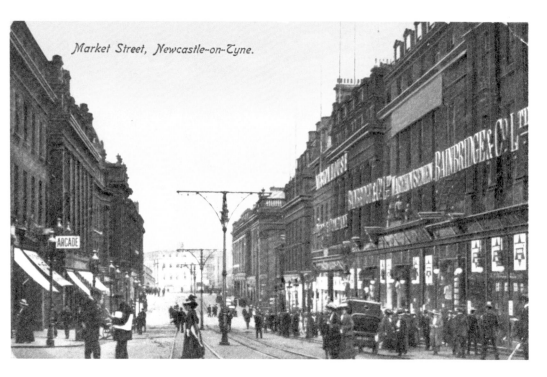

Market Street, Newcastle-on-Tyne.

Market Street

Built around 1840, Market Street connects Grainger Street with Pilgrim Street. Since the pedestrianisation of much of the area around the monument, Market Street has seen a great increase in road traffic. It is seen below during snowfall in the winter of 2010.

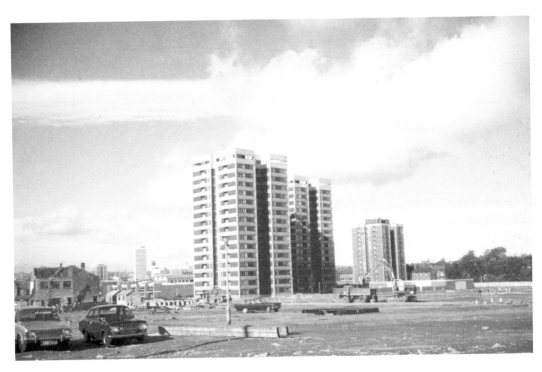

Blocks of Flats Taken from Belvedere Road, Byker

Byker has always been a strong working class area. Up until the 1960s it consisted of dense Victorian terraces, many of which lacked proper bathrooms and were falling into disrepair. Most locals wanted to stay local, however, and in the early 1960s the area was redeveloped with the aim of losing the slums while keeping the community. The advantage of tower blocks was that they could be constructed first giving the people something to move to, and then the old houses could be demolished.

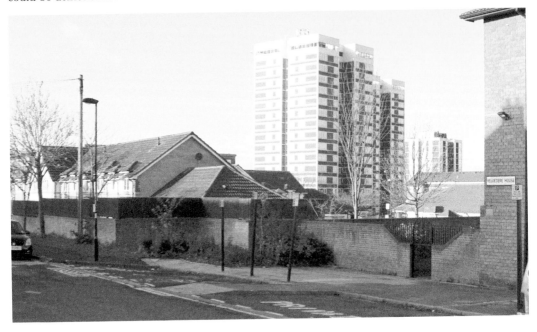

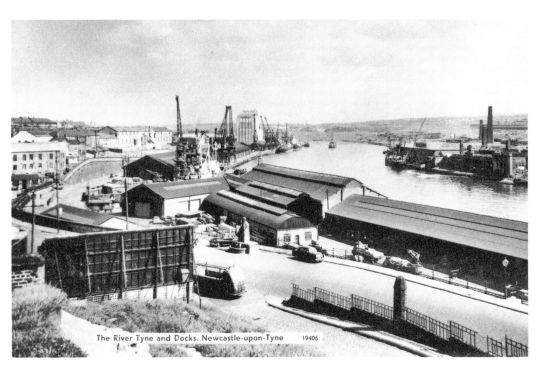

The River Tyne and Docks, Newcastle-upon-Tyne 19406

Glasshouse Bridge

The famous Glasshouse Bridge, linking the earlier and later Quaysides across the Ouseburn's junction with the River Tyne. The older picture shows very well how a complex series of sheds and railway lines filled the river bank from the swing bridge to beyond Spillers Tyne Mill, the largest flour mill in Europe. The bus shown in the modern picture is one of the short-lived electric buses put into service to link the Newcastle and Gateshead Quaysides. It is said that a driver could contact the manufacturer's support team directly from his cab all the way to New Zealand. However, the time difference must have led to some strained conversations when technicians were roused from their beds to answer a trivial question!

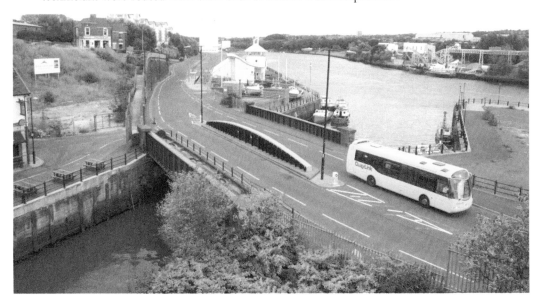

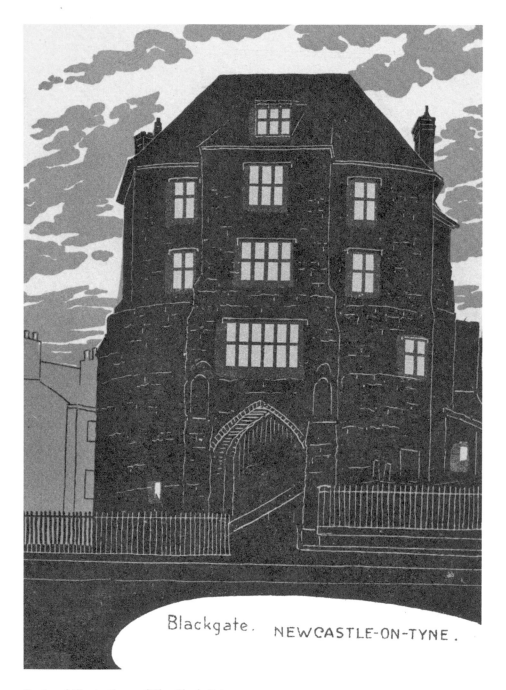

Blackgate. NEWCASTLE-ON-TYNE.

Postcard Illustrations of The Black Gate

The above being, we believe, one of a series by North Eastern Railway advertising Newcastle as a tourist destination. The 'Blackgate', as it is referred to above, was added to Newcastle Castle between 1247 and 1250. It featured a drawbridge at the front, and there was another at the rear and a portcullis. Its position allows it to observe the whole length of the western wall and ditch, and its angle meant that attackers were exposed to fire from the castle's defenders. The original roof was probably flat, although there seems to be no clear evidence of its original height and shape. Around 1618 the structure was leased to an

Alexander Stephenson who rebuilt the upper floors and let out the gatehouse. One tenant was named Patrick Black, and later gave his name to The Black Gate. The fortunes of this area of Newcastle declined and at one point the gate incorporated a public house and the rest of the structure became slum housing. In the late 1880s, the Society of Antiquaries of Newcastle-Upon-Tyne extensively restored the building and added the top floor and pitched roof. The Society has held regular meetings there ever since. The drawbridges to the front and rear have been replaced by wooden footbridges.

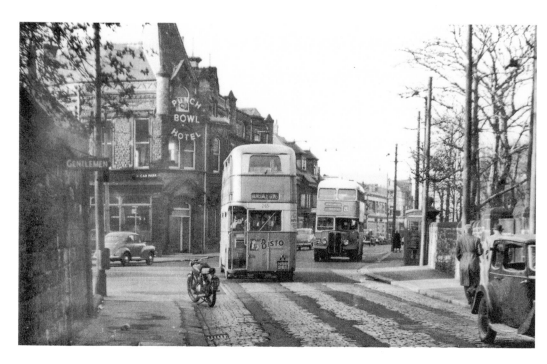

The Punch Bowl

The view of this location, where Sandyford Road joins Jesmond Road opposite the Punch Bowl Hotel, offers lots of transport stories. One of the first horse tram services in 1878 ran from the centre of Newcastle to 'the Minories' at this point, and later two electric tram routes converged here on their way eastwards. Evidence of the trams is shown in the hasty application of infill following the tearing-up of the track in Sandyford Road. The two buses both have bodies built locally in 1949/50 by Northern Coachbuilders in Claremont Road, little more than a mile from this spot.